ANNETTE ANNECHILD, MFT, LPC, PHD, was born in New York City and grew up in an Italian environment that revolved around family, friends, and food. Her earliest dream was to become an actress. After attending the University of Maryland, where she double majored in radio/television and psychology, she went on to the American Academy of Dramatic Arts. Soon after, she appeared in many off-Broadway productions and several television and radio commercials. In 1980 she combined her love of cooking natural Italian cuisine with her interest in performing and authored her first book, *Getting Into Your Wok with Annette Annechild*. She immediately went on a nationwide television and radio tour, where she was often described as "the young Julia Child." Annette went on to write six more cookbooks, all designed to help people lose weight with delicious, healthy foods. In 1988 she returned to school to focus on the underlying psychological reasons that caused some people to fail at their weight management goals. Having lost over fifty pounds herself, she believed everyone deserved the chance to be fit and healthy. In 1992 she completed her education and became a licensed psychotherapist, specializing in weight management, stress reduction, and women's issues. In 2000 she opened The Healing

Arts Center of Georgetown, a co-op of ten practitioners offering massage, chiropractic, acupuncture, meditation, psychotherapy, hypnotherapy, and weight management that thrives today in the heart of Washington, D.C. In 2003, Annette opened a second practice in Delray Beach, Florida.

During this time, Annette authored her eighth book, *Your Man and His Mother*, which was featured twice on *Oprah*. She has also appeared on hundreds of other shows during her career. Her personal and professional commitment to health and well-being brought her naturally to explore the subject of friendship among women. As a therapist, she has worked with hundreds of females of all ages, and as a woman herself, she still relies on a strong group of great girlfriends. Her fascination with relationships and how to improve them continues. *I Can Tell Her Anything* is her tribute to all she has learned from her friends, clients, and all the women surveyed across America for this book.

I can
tell her
Anything

I can
tell her
Anything

the power of girl talk

Annette Annechild, MFT, LPC, PhD

MARLOWE & COMPANY
NEW YORK

I CAN TELL HER ANYTHING: *The Power of Girl Talk*

Copyright © 2005 Annette Annechild

Published by
Marlowe & Company
An Imprint of Avalon Publishing Group Incorporated
245 West 17th Street • 11th floor
New York, NY 10011

AVALON

Library of Congress Control Number: 2004118078

ISBN 1-56924-392-1

9 8 7 6 5 4 3 2 1

Designed by Pauline Neuwirth, Neuwirth and Associates, Inc.

Printed in the United States of America

This book is dedicated to the incredible beauty and grace of the female spirit. To every woman who has had a great girlfriend and every woman who has been one. Most of all, it is dedicated to women who still long for that experience. And to my amazing partner, John Garner, who makes me glad every day that I'm a woman.

CONTENTS

If one could be friendly with women, what a pleasure—the relationship so secret and private compared with the relationships with men.
—VIRGINIA WOOLF

RYING TO DEFINE the essence of a true girlfriend is like attempting to describe the delicate splendor of springtime. A girlfriend is beauty and grace with arms outstretched to support and serve. She is love and honor, and laughter with smiles. Her friendship is easy and uncomplicated. Flowing around and over you, her spirit protects you. And she listens. A true girlfriend listens to your heart and opens your soul. You trust her, and in that trust you are connected, sometimes for the very first time in your life. A true girlfriend is a treasure to have and an honor to be.

But for some of us, that treasure is undiscovered. For others, it is tangled in a subtle web of conflict that makes friendship difficult and emotionally draining. Still others may not understand that deepening a friendship often requires opening up, and trusting your girlfriends with the tender secrets of your hearts.

This book gently describes and teaches the rewards and responsibilities of true friendship. It also unravels the mystery of finding friends and encourages thoughtful analysis of the women with whom we spend our time. The book teaches that

encircling ourselves with girlfriends who are caring and uplift-
ing, and have our best interests at heart sometimes requires
redefining friendships, and letting go of those that may be com-
fortable and familiar but damage us in some way.

And who could explore the complexities and joys of friendship
more openly and honestly than Annette Annechild, a person
who makes everyone feel like she's her best friend. Recently I read
a note given to Annette by her friend Lyndie, which included an
excerpt from the book *Grammar* by Tony Hoagland:

> *When she walks into the room,*
> *everybody turns.*
> *Some kind of light is coming from her head,*
> *Even the geraniums look curious . . .*
> *We're all attracted to the perfume*
> *of fermenting joy.*
> *We've all tried to start a fire,*
> *and one day maybe it will blaze up on its own.*
> *In the meantime, she is the one today among us*
> *most able to bear the idea of her own beauty,*
> *and when we see it, what we do is natural:*
> *we take our burned hands*
> *out of our pockets,*
> *and clap.*

To know Annette is to be immersed in light and bathed in love.
To feel her spirit is like dancing on clouds while feeling the
power of God. She is open and honest, sharing her failings as
easily as she shares her successes. And she so firmly believes in
the goodness of the human spirit that with her friendship, weak-
nesses become strong and darkness fades away.

Annette has much to teach women about the love and acceptance to which we all are entitled. Reading this book will transform you as a girlfriend and help you choose and build healthy relationships to enhance your life. So often it is within our friendships that we discover ourselves. This book is about that discovery, the sense of belonging that it brings, and the honor of having and being a true girlfriend.

—CHRISTY ROSCHÉ, a friend of Annette's

roadmap to
our souls

THIS BOOK BRINGS together the stories of over a thousand women across America. They were surveyed by phone and by mail in a random sample designed by the author and executed by researchers at the University of Maryland. It is one of the largest samples ever taken measuring women's attitudes toward each other. In addition, I talked to hundreds of women about their girlfriends, both in my practice and in interviews for this book. My research survey, coupled with their stories, reveals a riveting perspective on how females relate to one another throughout their lifespan. Our inquiries probed how women trust, how they betray, and how they ultimately need one another. A complete copy of the survey is included in the appendix of this book.

Over the past twenty years, I have had the privilege of being intimately involved with thousands of women. In my work as a psychotherapist, I witness their inner workings, listen to their stories, and hold forever their secrets. For me, it is no small thing. Every day brings me greater understanding, increased insight, and a deeper appreciation of the female spirit.

Nowhere is this spirit more evident than in the dance we do with each other. I have come to believe that as we connect with one another, we in some way define ourselves. Women who tell me they don't care for other women and don't want female friends eventually expose their disappointments, their fears, and their deep longing for more closeness. Although growing up in a complicated world has not been easy on women's relationships, stories of true sisterhood abound. The common message of the women surveyed throughout the country is that we need each other. Our relationships with men and family are not enough. We need the familiarity of our gender, and the very special relationships that spring from it. Although each of us can exist without girlfriends, there is an added richness in our lives if we embrace them.

This book is about that embrace. It is an inside look into the hearts and lives of women. It is about our power to connect with each other, about the safety within that connection, and about the roadmap it provides to finding ourselves.

sharing our stories of friendship

As I began the research process, it became quite clear that women wanted to hear what other women were saying, and everyone had so much to say. Women sought me out and practically insisted that I listen to their stories. They asked if they could bring their friends along to our meetings, and story upon story poured out. These women had been bursting with a storehouse of information, and at the first opening, it came gushing forth. I was overwhelmed by the depth and complexity of their tales. The relationships they discussed were not at all peripheral

to their lives, but in fact, rested at their very core. The simple act of exploring them proved remarkably therapeutic for many of the women I interviewed. Simply witnessing this outpouring affected me, the therapist, deeply.

There was a time when I felt somewhat disappointed and confused by my own female friendships. As my career moved forward, there seemed to be a widening gap between me and certain friends. At the same time, new friendships felt tentative. As the research results came in, it became clear to me that over half of the 1,052 women surveyed felt the same way. As their life goals changed, some of their friends were changing also. Understanding this helped me feel less guilty, less like a failure, and for some reason, less lonely. At the same time, I found I also was struggling with the shift I had made from single girlfriends to "couple" relationships. Many of these couple friendships seemed to lack depth and felt less fulfilling. Again, I was far from alone; 64 percent of the women interviewed reported feeling the same way. It was cathartic for me to realize that so many women were experiencing the same things.

Throughout the process of writing this book, it has been interesting for me to trace back to the start my most significant friendships. I came to realize that all of them began without much forethought. This was very unlike the manner in which I would begin a relationship with a man. In this situation, I would carefully evaluate his beliefs, morals, and character. Starting a friendship with a woman was vastly different. In the early stages of a female friendship, I did not consider any of those qualities. In fact, it seemed that I often gravitated toward friends who were tough and somewhat caustic. As I've reflected back on these early friendships, I can see that I initially felt I would be protected by their harshness. I now understand why this type of

friendship often left me wounded and confused. In reality, these women eventually treated me as they treated everyone else. Instead of being protected, I was injured by them. Ironically, I had never assessed their character upon meeting them, and then I was shocked when they betrayed me. It seems so simple and obvious now, but for years I was blind to this pattern.

As I read the stories of women from around the country, once again I realized that I was not alone. There were countless stories of betrayal, particularly of girlfriends seducing boyfriends and husbands. Is it really so difficult to identify a woman who will betray us? Is it that we don't initially consider our friendships as carefully as we need to? Do we pay so much attention to our male relationships that we ignore the selection process in our collection of female friends? Women are flooded with advice on how to be a better wife, lover, and partner, but where do we learn how to be a better friend? Who teaches us how to wisely choose the women who will become our sisters? Who trains us in the art of caretaking these treasured souls?

a roadmap to ourselves

Indeed, girlfriends help us to know ourselves. Our experiences with them help us clarify what we need, what we believe in, and what we cannot tolerate. As we discover our own patterns in friendship, new behaviors emerge. For me, this meant letting go of the friendships that were not healthy for me and turning more attention to those that enriched my life. In some cases, I needed to become a better friend. In other friendships, I needed to initiate more open discussions in order to address underlying issues that were creating distance. Finally, I saw the need to choose friends differently.

I began to seek out women who were not competitive with me, and who had similar values and ways of being. These women had purpose and character, and they valued our connection. I began to choose women who were happy in their own lives and working toward their own dreams. I learned to pay attention to my own level of comfort in the early stages of new acquaintances and not to ignore warning signs.

These changes have transformed the essence of my daily life and in some ways the very essence of me. I know myself better now. I am happier and feel more comfortable in my life.

This not only allows me to be a better friend, but also to accept the friendship offered to me in a deeper way. I can completely trust my friends now, and I can completely trust myself.

The beauty of the message uncovered on these pages is that it is both deeply personal and universal. The stories of women whom I will never meet have brought me closer to my own story, and they will bring you closer to yours. Their collective voice shouts our triumphs, our betrayals, our great need to connect with each other. It is a voice we cannot ignore. And if we listen closely to that voice, we can find our own exquisite harmony.

the family
we choose

s I sit writing in my hammock on a toasty Florida evening, I listen for the sound of my girlfriend's car. We will scoot off to a new Cuban restaurant in town, meet friends, and do what women often do with one another—eat. It's so nice to have a group of friends for an evening of girl talk.

I remember my mother and her girlfriends, who felt like aunts to me. Between games of penny poker and plates of cake, they watched me grow up, while I watched them laugh and talk and play for hours. They talked about their men, their problems, their children, their hopes, and their fears. From a young age, I witnessed the value of girlfriends. While so much of the world has changed, I find it interesting and even mysterious that the girlfriend relationships of my mother's era are remarkably similar to

my own today. Women of all ages seem to gather together whenever possible to enjoy each other's company.

In today's society, many women work outside the home. Divorce rates are on the rise, leaving many mothers to juggle home and family without a partner. Women are living longer and often survive their husbands. More and more women are choosing a single life over a marriage that is unfulfilling or damaging. But through all the changes in our world, the girlfriend relationship remains a constant. Groups of girlfriends have always created a family of their own, supporting each other, talking, listening, and holding sacred the time they can spend together.

Whether we manage children and husbands, or professions and investments, we have always needed to connect with other women. From the playground to the end of our lives, our female friendships often form the foundation of our lives and an invaluable part of our support system.

our friendship choices

The big picture of friendship includes many aspects. A true girlfriend *means* something. She is the person you can call in the middle of the night, and no matter what, she will help you. You can tell her anything. When you are sad, scared, or confused, she is the person you can turn to for comfort, caring, and advice. She is a true girlfriend.

Our choice of girlfriends has a tremendous impact on our enjoyment of life. Girlfriends are the family we select. They define our lives. Whom we pick and why we pick them often reflects our concept of family and our view of ourselves. There is only so much time to share in our busy lives, and there can be

a limited number of friends that you can serve with love and attention. Many women may be part of your social circle, but real friendship can be so much more. And achieving more takes time. Selecting the right souls to girlfriend, then, is no less important than selecting a mate. After all, most women will end up outliving their partners and spending their final years in the company of their girlfriends.

So what do we look for in a girlfriend? There is no single answer. We all need different types of friends. But there are some qualities that are inherent to the development of trust and love. A person of good character with your best interests at heart is fundamental. A person who can listen without judgment, and who respects your opinion, has the potential of becoming a real friend.

I recently received a card from a client that said:

when i first began therapy, I wished you were my friend and not my therapist. I longed to be one of your girlfriends, talking about important things over lunch or while taking a long walk. But over these months I believe I've discovered the essence of true friendship. You and I may never have giddy girlfriend chats together, but in your office I will always have a place to rest my spirit and free my soul. We will probably never shop or travel together, but I know I will always have someone who understands the depth of my heart. And that, I suppose, is true friendship after all.

The definition of a true girlfriend goes beyond simply sharing activities. It must include being heard and feeling understood. I'm

always amazed at how simply listening helps my clients. Strangers walk into my office, sit down, and tell me their stories. I listen intently, with an open heart. I offer my empathy. I give them a safe space in which to express themselves, without judgment. An hour passes, and as they leave, they tell me time and again how much better they feel. As a young therapist, it was surprising to me that the less I talked, and the more I listened, the better my clients seemed to feel. Ultimately, we accomplished more.

Over the years, I have come to believe that there is a natural healer inside each of us. If we are given respect, care, and safety, this natural healing can begin. Therapy is not about giving and receiving advice. I've learned that it is impossible for me, as the therapist, to know what is right for another person. But, through listening carefully to what people are saying, and mirroring it back to them, insight often occurs. Most people can find their own way, if given a loving space in which to do it. And wisely selected girlfriends can provide this healing environment.

Friends who are carefully chosen can offer much of what a therapist provides. This is not to say that people with psychological pathology, true mental illness, can be healed by their friends. But many people who seek therapy in today's world are highly functional and struggle in their daily lives with stress and isolation. These are the people who can greatly benefit from the intimacy that high-quality friendship offers. Trusted girlfriends, who are concerned with your best interests and well-being, can truly nourish and guide you. Friends who provide caring, comfort, and positive support can give life a whole new feeling. Many of the women I interviewed while researching this book told me that their girlfriends were their best therapists.

selecting our family of friends

As I analyzed my own friendships through the process of writing this book, I realized that "selecting" friends is much different from simply "collecting" friends. I had known one group of women for more than twenty years, and those relationships were solid and positive. The girlfriends with whom I was having problems were generally more recent friendships. These tended to be relationships that I had fallen into, rather than friendships I had consciously selected.

Reflection brought insight, and with it the courage to let go of the women I had simply collected. They were often competitive and critical and, in many ways, undermined who I wanted to be. I began selecting friends who were softer and happier in their own lives, with value systems similar to my own. Eliminating friendships that drained me provided me with more time for new and carefully chosen friendships to develop.

In considering the development of friendship, it occurred to me that most friendships fall into one of the following three categories: friends we meet by chance, friends we accumulate through convenience, and, finally, friends we actually choose. All three types of friends can be valid relationships in your life. Certainly, we can meet friends by chance or convenience who later turn into friends we choose for life.

friends of chance

Friends of chance arrive in our lives at any time and anywhere. We may take a trip and find them in the seat beside us on the

plane. We might attend a luncheon and find them placed at our table, or meet them in a group conversation at a cocktail party. Some women we meet in chance encounters initially attract us by a shared energy or intellect. Repeated chance encounters may also draw our attention to an individual. If we immediately assume that all such chance relationships are friends, then we are not selecting, but rather collecting girlfriends.

my best friend was a girl I met in seventh grade. Elementary school had been rough with a couple of "queen bees" making little social cliques that somehow I didn't fit into. It was wonderful to find a friend to talk with and grow with. We were best friends all through junior and senior high school. We had our ups and downs and grew from immature friendship with its jealousies, controls, and spats to a warmer, broader, mature "sisterhood" full of sharing and Christ-caring. She was my bridesmaid and the only person with whom, even after the miles separated us, I could still pick up the conversation when we next met. A husband and children now fill my time—but the friendship and life we learned about together is a warm memory.

It's important to find your way slowly with another person. It is critical to listen carefully to what your potential new friend is saying about her philosophy of life and ways of being. We need to observe all red flags and not decide that they are pink because we are hopeful for the friendship. If someone makes you uncomfortable, for whatever reason, listen carefully to your inner voice.

For example, a person who divulges someone else's secrets will likely divulge yours.

Friends of chance are an opportunity, but they come without any guarantee. Eventually, friends of chance may become chosen and valued girlfriends. Or, you may decide to let them slip away if they fail to fit with who you are and who you want to be.

Deciding whether to pursue a friend of chance or let that person go isn't very difficult. It simply requires reflection and trust in your own opinion. After all, no one can determine chemistry, and certainly in platonic girlfriends there is a certain "click" that needs to be there.

Someone's intellect, humor, or goals may create that "click." When you are drawn to another person, pay attention. Consider the elements of that attraction. A person who might not become a girlfriend can perhaps still teach you something, even if it simply reaffirms what you don't want to be. If your new acquaintance does or says something that is disturbing, take notice. Consider discussing it with her and clearing the air. If you hesitate to do this, or if you feel that it wouldn't be worth it, she probably won't become a true friend of choice. If she listens with empathy and explains the situation in a way that restores your comfort, you may well be on your way to a great friendship. When someone truly listens and cares about your feelings, you feel safe. Safety is an important element in friendship.

Pursuing friendships that are safe and comfortable can be followed by building a relationship that is truthful and in line with your morality. Sharing a mutual vision of the friendship desired is equally important in converting friends of chance to friends of choice. Finally, consider how you feel after spending time with her. If you are uplifted and happy, these are good signs that point in the direction of deep friendship.

friends of convenience

In our daily lives, we often come across friends of convenience. The mother of your child's friend, your next-door neighbor, or the woman who sits at the next desk would all be considered friends of convenience. These friendships can easily survive in the context in which they arrive, but many may not have what it takes to be a part of the bigger picture of your life. Good social relationships are integral to the happiness and ease of our daily routines. There is nothing wrong with a friendship that remains on the surface and is more linked to an activity than to your deeper emotional world.

my friend lynne and I were both "bus girls" at a Sheraton hotel, and we drove one another to work—she one day and I the next. We both had extremely long and very thick hair that we ironed back then and always wore down. One summer afternoon when it was my turn to pick up Lynne, I got to her house, blew the horn, and when Lynne came out she had her hair in pigtails and she looked at me and cracked up because I too (for some strange reason) was wearing pigtails, which I normally never did! It was the funniest experience.

Understanding the realistic and appropriate role that a person plays in your life can help you avoid misunderstanding and disappointment. We cannot expect that all of these relationships of convenience will become true friendships. Carefully

considering what you can receive from a relationship and what you are willing to give is an integral start in evaluating all of these connections. Your next-door neighbor might be someone that you choose to help in an emergency or enjoy at a neighborhood function. She may not, however, be the person to confide in or to spend large amounts of time with. I often see women who are disappointed when they burden a friendship of convenience with the demands of a deep girlfriend relationship. Suddenly pouring out your heart to another mother in the carpool might not lead to a positive or supportive result. That person may not be equipped emotionally to handle such a confidence and may not hold sacred the intimate material that you share. You may wind up feeling worse when that person does not respond in a helpful way. It may also become awkward to maintain the daily routines that you share after such an experience. Your inner world is sacred, and by evaluating your female relationships, you will know where and when to share the precious inner workings of your deepest self.

Love is risky, and all good relationships, whether platonic or romantic, involve the risk of getting hurt. Many women have told me that they have no girlfriends because they are afraid to offer friendship to a friend of convenience and be rebuffed. My advice to you is to take a chance. If you enjoy someone's company at your child's soccer games, invite her family over for a barbecue. If you car pool to work, but never speak to the lady beside you, start a conversation. So many people are lonely for that friendship connection.

Friends of convenience are everywhere in our lives, but sometimes we fail to recognize them. Are there any women in your life you have overlooked? Sometimes it is the quiet soul that holds the largest treasure.

Friendship of any sort needs to be mutual. Just as you may not select each person you meet to be a girlfriend, others may not as well. Being aware of another person's responsiveness to your overtures of friendship is equally important. If a person doesn't respond to your phone calls or invitations, you may need to gently let the idea of a friendship with that person go. It in no way means that there is something wrong with you. It may indicate that the person is too busy right now for a new friend, or there may be something so different about the two of you that the other person chooses not to go forward. When a friendship is mutual, it feels natural. It grows over time. Once again, a friend of convenience may eventually become a friend of choice.

friends of choice

The beauty of friendship is most apparent when we consciously choose with whom to create this marvelous connection. For me, it is most important to reflect upon how I feel *after* spending time with a new person in my life. Sometimes I come away feeling nourished and hopeful; other times I find myself feeling anxious or drained. I might not have been aware of these feelings had I not taken quiet time to allow these emotions to surface. I have conditioned myself to sit quietly after meeting with a new friend and to give myself time to reflect on how I am feeling. These moments lead to incredibly important information about whether a friendship is healthy and beneficial in my life. This is not to say that being challenged by a person is something to run away from. I'm talking about a general sense of my own well-being after spending time experiencing another person's world.

Once I had a friend of convenience whose conversation always

revolved around material possessions. What was on the cover of the Saks Fifth Avenue catalog could dominate a lunchtime conversation. She would move on to talk about new cars, bigger houses, and extravagant vacations. After these conversations, I found myself feeling anxious about money and indeed, a bit of a financial failure. In subsequent conversations, I tried to steer our discussions to areas I was more interested in and more comfortable with, but to no avail.

When I finally stepped back and honestly evaluated how I felt after our time together, I came to realize that she could never become a true, close girlfriend. As it turned out, our natures were so different that a true girlfriend relationship was impossible. I no longer tried to deepen the relationship, and though I had been hopeful initially about finding a new girlfriend, I had to accept that this person fit better into my life as a friend of convenience. We had a pleasant relationship in the years that followed, but it was sporadic and never grew. I felt I spared us both disappointment because neither of us was about to change the fabric of our lives, our goals, and our ways of being.

Sometimes what upsets you in an interaction may be subtle and require time to bubble to the surface. If you feel uneasy or uncomfortable, you need to pay attention and consider what is really going on between the two of you. When you have determined what bothers you, there are two choices. You may decide to retreat and let the friendship of convenience remain just on the surface of your life. Alternatively, there may be times when you choose to discuss these feelings with a new friend. Most people say they hate confronting others with things that might be difficult for them to hear. Confrontation is risky, and you must be prepared for the fallout that might occur. A person might react defensively and attack you in response. Holding to your own

truth is the best tack you can take. Your feelings are valid, even if another person doesn't agree with them. By going slowly, less damage is likely to occur to yourself or to your friend. With less emotion and time invested initially, it is easier to take a friendship on its own terms.

It's important to assess our friends and decide what category each person fits into. To force a friend of convenience into the shape of a friend of choice will only foster disappointment and anxiety. We need an assemblage of both categories of friends. Each is valid and each serves a role in our lives.

My friend Kathie and I are a good example of friends who met by chance, became friends of convenience, and ultimately became treasured friends of choice. We actually met in line at the Harbor Police Station in Washington, D.C., when we were both registering boats. During the wait in a long line, we started chatting. Kathie explained that she was the dock master at Columbia Island Marina. Two years later, I ended up with a slip for my boat at that marina. Friends of chance became friends of convenience as we discovered we were both avid boaters and were always looking for people who enjoyed boating as much as we did. In addition, I preferred captaining a boat, and Kathie was an excellent first mate. Together we were able to explore the Potomac River, and we got to know a lot more about each other. We both commented that we felt like little girls who had met a new friend in the neighborhood. Over time, our friendship deepened, and she clearly became a friend I chose and whose company I really enjoyed.

Little did Kathie and I know that our trip to a Miami boat show would change our lives forever. We ended up staying in Florida longer than expected due to a treacherous snowstorm in Washington that forced all the airports to close. When my long

time Floridian girlfriend, Lani, learned we had an extra day or two in town, she suggested we meet in Delray Beach for dinner. The short ride we took after that dinner moved my life in an unexpected direction. We drove past a beautiful house, which I fell in love with immediately. I am not normally impetuous, but September 11 had convinced me that I no longer wanted to live in the nation's capital.

The next day I made an offer to buy the property. The offer was accepted, and this put in motion a series of events that resulted in changing my home, my life, and my vision of the future. Unbelievably, Kathie, who had lived in one city her entire life, decided it was time for a change also. She bought a home just five blocks away in Delray Beach and got a job managing the local beach club. Both of us were single at the time, and without the support of one other, this move might have been too much to handle for each of us.

We have been in Florida over a year now, and we both agree it has been the best year of our lives. At ages forty-three and fifty-three, we have created a new world for ourselves. We talk often about the bravery it took to make this move, and how we could never have done it without the support of our girlfriends, especially Lani. Each day, when I take my bike and run my errands in this beautiful town, I can hardly believe that this is my new life. Each time I pull into the driveway, I pinch myself to prove that this is actually my home. Friends of choice made this new life possible.

When I made this move, many of my clients were upset that their therapist was leaving town. My parents thought I was crazy to make such a move at my age and risk damaging my successful business. My close friends in Washington were aghast that I was leaving. Kathie met with the same resistance, especially

when she quit her job after twenty-six years of continuous service with the same company. We both agree that the act of leaving Washington was one of the most difficult things we have ever done. We depended upon each other for support. We encouraged each other's dream and helped make it come true.

As it turned out, I was able to maintain my practice in Washington and continue to serve my clients, as well as visit with my friends and family often. The team of people who work with me in Washington comprises young doctors, who have had the opportunity to step into a larger role in my Healing Arts Center. In the year that followed, several of my clients went on to make great changes and take chances as never before. Many of them said that they were inspired by my move and empowered by it to make their own. My decision to be brave and my girlfriend's decision to take a chance could not have happened without our support of each other. I certainly chose a true girlfriend when I chose Kathie.

analyzing your family of friends

In family therapy, creating a "genogram" is an effective tool for evaluating the configuration of personalities within a family and the patterns they create that flow through generations. Constructing a genogram is very much like creating your family tree. It's always enlightening to see the picture of your life on paper.

As the girlfriend surveys were evaluated for this book, it became clear that women wanted guidance on developing, understanding, and enriching their friendships. This prompted the adaptation of the genogram from families to friendships. I named

this adaptation the "girlogram." Just a pencil, paper, and a few moments of your time is all you need to create your own girlogram and put yourself well on the way to viewing your friendships more completely. I am amazed at the clarity that my own girlogram offers me, and I have included it, as well as a generic example, in the chapter that follows. I have asked each of my girlfriends to create their own girlogram, so we can share them with one another. I recommend you do that with your friends too. Until I completed my girlogram, I had never realized that my own friends include women from twenty-five to eighty-five years of age, and that the years of friendship they have offered me range from just a few years to more than three decades.

If you choose to come along, this book can help you shape and improve the friendships in your life. You can evaluate them, change them around, and learn to celebrate them completely. You may also learn how to become a better friend yourself.

Girlfriend therapy

To **help you** determine whether a friend of convenience or chance should be considered as a friend of choice, consider the following questions. They can help you decide whether to continue down the girlfriend path.

1. How do I feel after I spend time with her?

2. Am I proud to know her?

3. Do I want her influence in my life?

4. Do her stories reveal a person of integrity?

5. Does she bring out the best in me?

the girlogram:
analyzing your friendships

THERAPISTS HAVE USED the genogram for years to help clients understand the constellation of their family members. It's a simple and quick way to create a visual map of the web of relationships that composes a family. In this case, it's clearly true that a picture is worth a thousand words. The girlogram is my adaptation of this therapeutic tool. Your girlogram will be easy to create and will provide you with all sorts of information about your circle of friends.

creating your girlogram

Step 1: On a plain sheet of paper draw a small circle in the center and place your name inside it. Then begin thinking about the women that you consider to be your friends.

Sample Girlogram

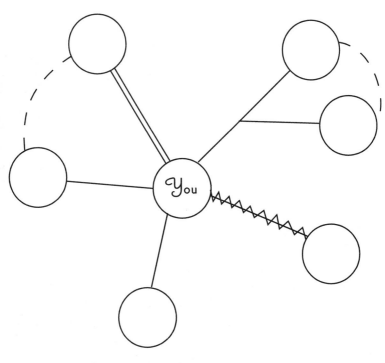

	MET THROUGH ANOTHER FRIEND
	FRIENDS WHO BECAME FRIENDS THROUGH YOU
	FUSED, CODEPENDENT
	DISTURBED, ANGRY
> <	GIVING IN ONE DIRECTION

Annette's Girlogram

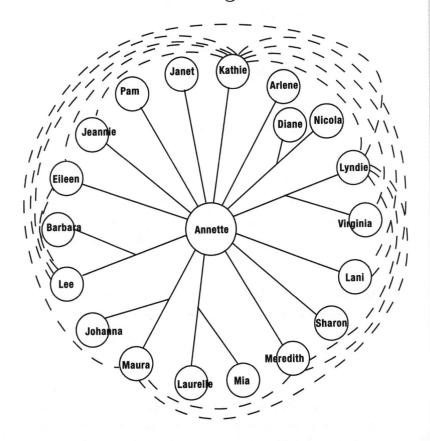

Step 2: Draw lines extending from your circle, and place your girlfriends' names at the end of each line. If you have met one friend through another, place the second friend on a branch off the original line. The concept is similar to a map of the solar system with planets circling around the sun. In the girlogram, your friends' names orbit around your own name.

Step 3: If any of your friends have now become friends with each other, draw a dotted line between them.

Step 4: As you read through the chapters in this book, you will consider the depth and value of each of these friendships. You can then add more information to your girlogram. If you find that you have a disturbed, angry, or conflicted relationship with one of your friends, indicate this by drawing a jagged line over the original straight line connecting her name with yours.

Step 5: If you find that any of these friendships feel smothering, make the connecting link a double line.

Step 6: At this point, you can begin to consider how this circle of friends feels in your life. Throughout the chapters of this book, use your girlogram as you work through the questions in each "Girlfriend Therapy" section of the book. Your girlogram combined with the "Girlfriend Therapy" exercises will help evaluate your friendships and determine whether changes should be made within your circle of friends.

Step 7: Trust, betrayal, intimacy, and comfort are some of the topics that will be explored. With your girlogram at hand, you can

start to evaluate and expand your girlogram to include notes that describe each of these friendships.

about my girlogram

If I had created my girlogram a decade ago, there would have been several jagged lines and double lines within it. As my understanding grew of the great impact that girlfriends have in each other's lives, I worked toward transforming and, in some cases, letting go of those relationships that were unhealthy for me. At one point, there would have been far fewer names on my girlogram. I was amazed, when I constructed my girlogram for this book, at how many wonderful friends I now have in my life.

Today, as I consider my circle of friends, I realize that what these women have in common is that they live their lives in a heart-based manner. There is not one person in this group who would intentionally hurt my feelings or betray me in any way. I feel that I can trust all of them with my life. By their very existence, each of them brings a gift to my family and me. Years ago, I decided that what I needed most in friends was gentleness and a shared philosophy of living. Though many of my friends are quite ambitious, our mutual desire is for a life filled with truth and love.

As you can see from my girlogram, many of these women have become friends with one another. The fact that we all share similar values has made it very easy for these women to connect with each other, despite the fact that we all have very different lives. It's also important to consider who you are in each of your friendships. Ideally, we can be our true selves with all of our friends. You may enjoy different activities with each of your

friends or find that different aspects of your personality are brought forth by different friendships. However, you need to feel safe enough to express your ever evolving self in a healthy and growing friendship.

the competition factor

When friends of yours become friends with each other, problems can arise. Competition and jealousy can easily surface. How you handle these feelings is important. If you believe, or want to believe, in the concept of *abundance*, you can reassure yourself that there is plenty of love to go around. If you believe in a spiritual flow to life, you can remind yourself that you will always get what you need. If you practice generosity, you will be glad if two friends meet and spend time together. However, such highly evolved feelings are not always easy to come by.

When I was still in the phase of my life where I was "collecting" instead of selecting girlfriends, I introduced an old friend to a new one. They totally hit it off and eventually began to exclude me from their plans. When we were all three together, I sometimes felt as though they had private jokes or understandings that excluded me, which made me feel uneasy, even jealous. Later, when I became more adept at evaluating my friends, I understood that neither of these women was a true friend, and I edited them out of my circle.

If unpleasant feelings arise for you around this issue, take a self-inventory. Are these feelings coming from personal

insecurity, or are they rooted in reality? Are these women true friends? Can you talk about it with them and be heard, understood, and nurtured? If not, you may want to move on to better and more supportive friendships.

Girlfriend therapy

1. Analyze the women in your girlogram, and on a sheet of paper note how you became friends with them in one of three categories: chance, convenience, or choice.

2. Now analyze these three lists (chance, convenience, and choice) by answering the questions on page 22 in Chapter 1.

3. Review your findings. Note friendships that seem easy and uplifting versus those that may be draining and difficult.

4. Generally analyze the friends you've "selected" and the friends you've "collected." What does each set add or take away from your life and/or goals?

5. You can create an outer circle and move names a step removed from your inner circle of best friends.

how girlfriends connect

MOST OF THE 1,052 women who participated in my survey stressed the importance of women's friendships in their lives. Over 90 percent of the women surveyed rated their friendships as important, very important, or extremely important. In emergency situations, women reported that they turn to each other as their first choice after their partners. In an emotional crisis, women turn to both partners and girlfriends equally. Even when adjusting to a new living environment, after our partners, it is our girlfriends we turn to most often.

One of the clear points revealed by our research is that most women desire a lot of connection with other women, and that we share our deepest selves most often with each other. As a therapist, I repeatedly listen to women in my office revealing something to their spouse for the very first time. It's as though they have lived

a separate life within themselves for years, and then, in the safety of my office, the dam breaks. Suddenly, layers of inner thoughts and feelings fill the room. The partner is usually shocked and over-whelmed that this information was stored inside his mate. These same women very often tell me that their girlfriends know them completely and say that they have discussed all of this information with them for years. I find it interesting that a majority of the women that I interviewed reported telling their girlfriends dif-ferent things from what they tell the men in their lives. For exam-ple, girlfriends tend to share their complicated emotional worlds. We talk about men, and how different they are from us. We dissect our relationships. In essence, girlfriends have a unique language that is understood only by them.

Girlfriends can teach us how to trust ourselves with another person, which in turn helps us learn how to connect with all the important people in our lives. All of us need to connect in order to find contentment and happiness. Having a network of sup-portive girlfriends can completely transform our experience in the world. There is a true joy in knowing that you can play, cry, and discuss even the most mundane daily tasks with a friend. Girlfriends often make the difference between loneliness and a life filled with empathy, happiness, and joy.

girlfriends help us feel safe

The great majority of women surveyed describe their girlfriends not only as the people they confide in most and tell their deep-est secrets to, but also as the people they feel closest to and most understood by. A majority of women also believe that most women treat each other like sisters.

The *Oxford English Dictionary* defines intimate as "pertaining to the inmost thoughts or feelings; proceeding from, concerning, or affecting one's inmost self; closely personal." Clearly, these survey responses indicate that we are, in many ways, most intimate with our girlfriends. I have often heard women jokingly say, "If you were a man, I'd marry you!" *Why* we are so intimate with our girlfriends is an interesting question to consider.

The familiarity of gender certainly may play a role. Yet, these women reported more intimacy with their girlfriends than with their mothers or their sisters. Therefore, gender can't be the whole story. I believe it's because our girlfriends allow us to reveal more of ourselves. When I see a group of women together, I often notice that they seem far freer than they do in couple situations. I watch my own girlfriends laugh loudly, talk feverishly, and smile more completely when we are together without our men. In these moments, they remind me of when we were very young and free, before we became so aware of what we were supposed to be, or how we had to be in order to please others.

In Mary Pipher's remarkable book *Reviving Ophelia*, she describes so beautifully this untamed part of our lives, saying that in adolescence "girls become 'female impersonators' who fit their whole selves into small, crowded places. Vibrant, confident girls become shy, doubting young women. Girls stop thinking 'Who am I?' 'What do I want?' and start thinking 'What must I do to please others?'" Pipher also quotes Simone de Beauvoir, who believed adolescence is "when girls realize that men have the power and that their only power comes from consenting to become submissive, adored objects. They do not suffer from penis envy as Freud postulated, but from power envy."

Perhaps trusting each other with our most intimate selves in

some way helps us to reclaim some of that which was lost in adolescence. Maybe our power grows in each other's presence. In a safe girlfriend relationship, we don't have to censor who we are. There is a feminine understanding and interpretation of the world that exists between us. We don't need to explain ourselves; we know instinctively what the other is saying. As a marriage counselor, I listen again and again to a partner's disbelief at the different recounting of a shared situation in their lives. I encourage my clients to acknowledge the great difference in the genders. I have often heard the woman say, "If you loved me, you could not have done that." The truth is a man might love you very much and still do something you find offensive.

The similarity of spirit among girlfriends is the foundation of a friendship connection. I know that for me, girlfriends are my sounding board, and as I tell my tales of living, their understanding strengthens my own belief in my own perceptions. It's as though a small voice says, "See, you're not crazy. She understands the hurt or the anger, or the sense of injustice I feel." This voice helps me stay with myself, not to move away from my feelings but to move toward them, allowing me the necessary privilege of experiencing my true self.

Whatever we theorize is the reason for this intimacy between girlfriends, one truth that emerges from the research is that these women feel safest with their girlfriends. When we are truly emotionally intimate with someone, we are sharing our deepest selves. To do that, we need to feel safe. By their responses, these women are saying, "I feel safest with my girlfriends, safe to be myself, safe to share my secrets. I know my girlfriends will understand and help me through." The fact that a majority of these women feel that way is such a positive statement about the quality of our friendships today.

For those women who did not feel similarly, perhaps this information will shine a light on what is possible. Selecting girlfriends that enhance your life requires the same attention necessary for selecting a mate. Your girlogram will help you evaluate the current friendships in your life, and help you make decisions about friendships in the future. The truth is that we can choose either abusive people or nurturing ones with whom to have a relationship. It is our choice. Just as with a man, good relationships are possible. If you are in one, you need to nurture it. If you are not in one, perhaps it's time to reconsider your options.

building trust

In our survey, we found that women trust their girlfriends second only to their mate—more than their mother, father, siblings, or therapist. More than 80 percent said they would trust their best friend with their man for an extended period of time. According to the *Oxford English Dictionary*, trust is "confidence in or reliance on some quality or attribute of a person or thing." The fact that women trust each other so much is the foundation of their strong connections with each other. Trust must be earned and can easily be shattered, but these women, in the great majority, expressed continued trust in their friendships.

Trust is essential in any relationship. Without it, there is no stability over time. Some people have a hard time trusting anyone because of their history. Therapy can be a great help in this regard. As trust grows between the client and therapist, it even-

tually is generalized by the client into other relationships in her life. The therapeutic relationship can model what true respect and consideration feels like to an individual who has perhaps not received that type of treatment in the past. A good friend can model these attributes as well. Women who don't trust men because of bad past experiences often begin to trust again through their relationships with their girlfriends.

Of course, it's important to pick the right people to trust. The girlogram can get you started on this path. My young clients trust everyone easily and are disappointed often. It takes time to know someone enough to base trust on reality. If we carefully consider what is going on in the beginning of our relationships, we can make wise choices. Deciding to trust another person involves instinct and feeling. The decision should also take history into consideration. The best predictor of a person's future behavior is their past behavior. Being trustworthy is a character trait that rarely changes much over time.

An interesting survey question we asked was, "Would you trust your best friend with your husband for an extended period of time?" The fact that over 80 percent of these women trusted their girlfriend and partner enough to answer yes is such a positive statement about their own personal security and self esteem. This question provided a glimpse into trust in action. These women didn't just assume they could trust their girlfriends, they *knew* they could trust them with their most valued relationships.

when trust is broken

Whenever the bond of trust is broken, it is difficult to rebuild it. There are no clear-cut definitions of what trust and betrayal

entail. Each of us has the right to define what unforgivable behavior is. Sometimes even a small act of inconsideration is enough for us to question the value of a particular friendship, even if others say, "You're overreacting—it's no big deal." We are all products of our unique life experiences, and what is acceptable to one is not necessarily acceptable to others.

Certainly, forgiveness is easy to champion, but true forgiveness takes time. In some cases, you may choose not to forgive, and that is okay. You get to decide. Sometimes you can forgive the act, but not the character of the person who betrayed you. It is so important to listen to your inner voice, your instinct, your "gut." Most of all, if you are betrayed, it's important not to let distrust mar your future relationships. Talking about the pain and the loss with your other friends will help you dispel it. To turn your back on all women if one betrays you is a huge loss for you and a victory for the darkness of life.

sharing time

We cannot discuss friendship without considering the factor of time. The women surveyed were divided almost equally between feeling they did and did not have enough time for their friends. Age and marital status did influence this question. Women between thirty-five and thirty-nine years old reported the most difficulty in finding enough time for their friends. These are typically busy years for women who compete in the workplace, who are raising children, and especially those who are attempting to do both. Women sixty to sixty-four years of age, as well as widows, responded that they did have enough time for their friends.

Most women feel there are limits on their friendships because

of the amount of time their girlfriends have for them. If we look at the larger picture this research provides, it follows that women would want more time with the people they enjoy doing things with. As we get older, we long to recapture the luxury of shared time that we experienced in our youth.

When you compare the time availability of the average high school student to a woman over thirty, it's a study in contrasts. High school is a strong bonding time for women. In high school, girls get to "work" together, eat lunch together, and commute back and forth with one another. And that's before they get to social time. It's no wonder that these are the years we experience so many firsts with our girlfriends and miss them to this day.

During these years, women report having the most friends and spending the most time with their friends. In adolescence, as girls leave their families emotionally in order to individuate, their girlfriends become the most important people in their lives. We have found from the research that this sentiment continues quite strongly. Girlfriends remain throughout our lifespan one of the most important relationships in our lives. Hopefully, these younger years lay the groundwork for the many wonderful years of friendships ahead.

staying connected

Throughout the interviewing and surveying process, the theme of women enjoying each other in the world was a strong one. Women love talking together. A study published in the Women's Studies International Forum confirms that talk is central to close friendships between women. The women studied reported

that talking with their close friends "created a mosaic of noncritical listening, mutual support, enhancement of self-worth, personal growth and self-discovery." In our study, more than 90 percent said both phone and face-to-face contact with their friends was important to them.

Many women said that while talking was their favorite pastime, they consider working, creating, shopping, and eating fun, too. Many women I interviewed reported taking vacations with their girlfriends. I have seen many of my clients benefit greatly from such a trip. There are single women who might not travel at all if they did not have a girlfriend to go with. Some women described creating a money "kitty" with a girlfriend and then using it for road trips together. Others described their "rules for the road." Single women had rules like "No one goes home without the other" or "If you meet someone, see if he has a friend."

Married women talk about loving time with their girlfriends "without any responsibility for husbands or kids." Married women often enjoy certain vacations that their husbands would consider hellish. The trips to a spa, or a day at the beach or mall are good examples of what women like to do without their partners. The fact that women now often have their own money can make such vacations and days out possible. No matter what women describe doing with each other, their enjoyment in being together is clear. After their mates, women most enjoy staying connected and spending their free time with their girlfriends.

staying connected with your friends

1. Try to set up a regularly scheduled time to see each other, even if it's once a week, month, or year.
2. Meet a friend for a quick coffee break while you're out running errands.
3. Write important dates for your friends in your calendar (like birthdays and anniversaries) and be sure to call them.
4. Send cards or little gifts to your friends every once in a while just to show them you care.

maintaining quality of contact

To maintain a depth of friendship, both people have to be comfortable with the level and quality of contact. Women told us that they saw their best friends from as frequently as every day to as infrequently as just once a year. Sometimes it's a good idea to explain to a new friend the amount of time you have available for the relationship, and also what you might expect from her. It's so easy to hurt someone's feelings or to experience rejection yourself. Some friendships end because of a simple misunderstanding. Once again, communication makes all the difference.

I myself have had to explain to new friends the fast pace and busy schedule that is my life. I connect with many of my girlfriends on a weekly basis, but generally by phone. My friends understand that at this point in my life, this is all that is possible for me. They also know that if they need me, I'm instantly available and will do whatever it takes to protect and support

them. Accepting what another person has to offer and being honest about your own needs and desires clears the way for a solid foundation of lasting friendship.

In the end, there is no substitute for looking into someone's eyes, or seeing her laugh, and hearing her familiar voice. A hug is worth a thousand e-mails. Being flexible is a great asset in friendship building. I appreciate it when my friends make it convenient for me to see them when my time is limited. I have known people who kept requesting contact but who never made it easy for me to see them. If you are feeling lonely, it is important to be willing to get in a car, get on a plane, or do whatever is necessary to get the face-to-face contact that you need.

For me, having a fixed schedule with my friends helps me maintain face-to-face contact. For instance, I have been enjoying lunch with my friend Pam every Thursday whenever possible for the last ten years. I travel to Washington one week a month, and every Monday night that I am there, I meet my friend Maura for a great dinner in our favorite restaurant. Meridith and I always catch a breakfast on Tuesday morning, and on Thursday night, it is dinner with my girlfriend Lyndie and her husband, Curt. Without these scheduled events, our friendships would not be nearly as intense as they are today. We all look forward to these plans and take comfort knowing we have this specific time set aside for our friendship.

Participating in activities that you mutually enjoy is also a great way to stay connected. I go boating with my girlfriend Kathie, I fish with Eileen and her husband Ed, and I have taken rowing lessons with Maura. Without my girlfriend Jeannie, I would never have learned to paint, which is now one of my passions. Virginia and I are in the midst of writing a book together about ageless beauty. My friend Arlene introduced me to the art

of flower arranging. I work more than forty hours a week and travel extensively, yet I have found a way to stay connected with my friends. We make plans in advance and hold to those plans without exception.

One of my favorite examples of staying connected comes from my good friend Maura. This is her story:

Jane's brilliant husband is the reason that I met her. He was a successful lawyer practicing in Washington, D.C., and at the time, he was competing with my father's law firm. Because of his skills, my family was interested in recruiting him into my father's firm. During that process, my mother and Jane developed a deep friendship.

At the time I was just fifteen years old. Jane was in medical school. She was already a remarkable woman, raising three young children while studying full time. Through her connection to our family, she encouraged me to leave behind my "candy striper" uniform and to see another side of medicine. Instead of volunteering, I started accompanying her to medical school classes and attending a number of lectures, including the gross anatomy classes. I became fascinated with the subject of the human body. We remained close friends throughout her schooling, despite a fifteen-year age difference.

Four years later Jane was completing her residency in pediatrics, and I had become a college student, still undecided about my own career path. I was following through with my plans to become a chemical engineer. During my holidays at home, I joined her on call at the hospital, where I witnessed cesarean sections and even helped resuscitate

babies. This remains a completely compelling memory for me of our time together. My appreciation of her skills and passion eventually encouraged me to study in the same field.

Jane's connection with my mother and our family never wavered. Over the coming years, while I was still in college, Jane progressed in her medical career. She was eventually appointed assistant professor of pediatrics at Georgetown University. Unfortunately at this time, my mother became ill with ovarian cancer. Despite her commitments to her family and work, Jane was unfailingly at her side throughout a difficult year-long illness. Although my mother passed away, our bond of friendship grew even stronger.

Over the next thirty years both of our careers progressed. She was appointed professor of pediatrics at Georgetown, and I became a family doctor. Jane's husband even took my wedding photographs. We all enjoyed a fishing trip together every year. We would meet up at the law firm parties and share stories about our practices and work. Occasionally we would have the opportunity to share dinner together despite our challenging work schedules. Throughout these years, Jane remained my mentor, continuing to challenge me and encourage me in my development as a practitioner and teacher of family medicine.

Health issues continued to challenge both of our families. Jane's husband was diabetic, and my dad developed a debilitating illness that required full-time nursing care. I would visit my dad almost daily, and besides me and my brother, Jane and her husband were his most consistent visitors. He had lost his vision, and she could still find the time to read him the newspaper.

After my father passed away, I learned that complications of diabetes had taken their toll on Jane's husband's health. I will never forget the telephone call from her late one Tuesday evening when I was driving home. Jane told me that her husband was in the hospital and was very ill. I turned my car around and went straight back to the hospital. When I got there, I found that he was semiconscious and gravely ill. Despite his desperate struggle, he still recognized me, and welcomed me. The joy that he expressed while I retold stories about him and my father and brothers during their fishing exploits was evident. He passed away just hours later.

Jane and I are now in a new phase of our lives. Perhaps it is my turn to mentor Jane in how to live as a single woman and for me to encourage her to optimistically face life's day-to-day experiences. Her most compelling characteristic is still her intellect, and that has never failed her. My friendship with Jane has spanned more than thirty years and has shaped my life in so many ways. Our powerful girlfriend connection continues to this day. Whatever the future brings, I know that we will always be there for each other.

\mathscr{G}irlfriend therapy

1. Refer to your girlogram and analyze the connections you have with your friends. If a relationship feels one-sided in the giving or receiving department, draw an arrowhead on the line pointing in the direction in which the flow of the relationship is currently headed.

2. List those friends you can trust and who make you feel safe.

3. Now, list the friends with whom you share the most time.

4. Analyze your time spent with friends. Are the friends you're spending the most time with the friends you actually trust and with whom you feel safe? If not, why not? Are the friends who receive most of your time the friends you have selected, or are they simply friends you've collected?

5. Analyze the quality of the time you spend with each friend. Does the time you spend together enrich your life?

6. Make a list of the friends who consistently enrich your life.

7. Determine whether you need to adjust time allocations with your friends to allow growth in healthy relationships. Note ways you can maintain quality contact with the friends who enrich your life.

women
in conflict
4

SARAH AND I met as colleagues on a book project and became instant friends. We worked well together and had a tremendous amount of fun. Our friendship continued long after the book project was completed. We laughed together, traveled together, and shopped together, and I even took care of her for several months after she was injured in a serious fall. Sarah bought a home in the south of France and invited me to take my first trip to Europe to visit her. A whole new world opened for me, and I continued to take many trips to France over the next several years. We spent an enormous amount of time together, and she taught me so many things. I had a wonderful time and thought she was a friend I would know forever.

But then I started dating a man, and Sarah became interested in him as well. By a twist of fate, one day my telephone answering machine recorded a call between the two of them. It was clear they had an intimate relationship of which I was completely unaware. I was shocked, but I still tried hard to work through this betrayal and save our friendship. I felt indebted to her and cared for her deeply. Interestingly, I ended the relationship with this man (as did she) and focused on salvaging my relationship with my girlfriend. Our friendship actually survived for a while. Eventually, however, she fell in love with another man and decided she no longer needed my friendship. She began treating me with disrespect, and during a visit in France I left her home, cutting short a trip we had planned for months. The second betrayal caused me to reevaluate this friendship, and I knew it had become unhealthy for me. We have not spoken since.

The women that we surveyed shared many stories of betrayal by girlfriends in their quest for a man. However, the majority of these women reported that they had stayed true to their friendships, even during periods of serious conflict. The fact that conflict does not always cause women to end friendships abruptly is one of the most optimistic findings in our survey. With so much controversy in the world, in families and in couples, women reported surprisingly little unresolved conflict with each other. Most women said they never argued with their girlfriends over serious personal matters.

types of conflict

While these results are quite heartening, as a therapist I wonder if conflict among women often goes unacknowledged and,

therefore, underreported. I hear a lot of stories that involve terribly hurt feelings and confusion. Very often the stories are never shared with the person with whom the conflict arose. Often my clients will say they would rather forget what happened than take the risk of confrontation and perhaps loss of the friendship. This strategy can be effective for small things, but when a major betrayal has occurred, only talking it through can restore the friendship to its original levels of trust and intimacy. If there is disrespect, or if the harm is intentional, it may be impossible or unwise to proceed. Women often act out the "peacemaker" role they are raised with. They frequently overlook the problems that can compromise true and meaningful friendships. In the following pages, I will examine the leading sources of conflict that damage women's friendships.

control

Almost half of all women surveyed reported feeling controlled at some time by a female friend. As with so many of the topics in this book, control isn't always easy to define. There are obvious attempts to control another person, like telling her what to do or insisting on a certain behavior. Then, there are relationships where control starts slowly and subtly. It may begin with expressions of displeasure about one thing that a person is doing, and then escalate into more areas. Often, the person being controlled tries harder and harder to please the other person. When she fails, she often begins to feel guilty and bad about herself. "It must be me" is a statement I have heard again and again from women in the grip of a controlling relationship. To be controlled is to give up our own power and to become dominated

by a friend's opinion or point of view. Control is always a form of manipulation. As this next story illustrates, control can be subtle and even be disguised as nurturing.

As a twenty-three-year-old in a big city, several thousand miles east of my rural hometown, I found myself alone in a way I'd never been before. On one of my first Sundays in this new area, I met Kate. She was bubbly and vivacious and seemed to be in the middle of everything. She knew everyone, and everyone knew her. After her roommate became ill and moved away, Kate asked if I wanted to be her roommate. The day I arrived, Kate's living room was filled with friends having a party while watching a favorite television show. Her apartment was beautifully decorated and smelled and sounded like the home I had always longed for.

From the time I moved in, I was enveloped by Kate's warm and nurturing personality. I'll never forget my first Christmas there, the beautiful decorations, the parties, the food, and the friendship. While I can't remember the gift she gave me that year, I vividly remember the wide, satin ribbon that was tied into a gorgeous bow on top of the gift box. I'd never seen anything like it.

Over the past two decades, as I've started my own event business and given workshops on gift wrapping, flowers, and entertaining, I've credited that beautiful bow and Kate's spirit with opening up a creative side of me that I didn't even know was there. She shared her possessions and her home freely. She helped me make big and small decisions. We laughed together. We talked for hours together. She constantly praised me, and celebrated my gifts and talents. We'd set out for road trips on a whim. And I trusted her. For the first time in

my life, I trusted someone completely. Little did I know there was going to be a price to pay.

This newfound trust was probably why our occasional arguments were so devastating to me. Looking back, in all the nurturing, there was an element of control that seemed to motivate Kate. While my childhood had been cold but stable, hers was passionate and frenzied. Her parents were divorced, and her relationship with her mother had been volatile. In some ways, Kate was my opposite. I grew up not trusting anyone and protected myself by keeping people at an emotional distance. She seemed to stabilize her world by drawing people close and controlling them in a nurturing sort of way.

It was my boyfriend who first noticed this pattern of control. While he thought Kate was wonderful, there was something that kept him from trusting her completely, and he was baffled at how complicated things became whenever we included her in our plans. And while she always went out of her way to help us, he noticed that she seemed to keep score—and that I was always in arrears. I defended Kate and believed her scorekeeping was accurate, since my siblings had long ago labeled me as the selfish, spoiled baby of the family. With Kate, who gave so much, I always felt indebted.

This feeling of indebtedness was accentuated when my boyfriend and I broke up. I had dated my boyfriend for several years and was devastated when he told me he wanted to see other people. I couldn't eat, and I sobbed uncontrollably for a month. Kate spent hours consoling and caring for me. But as I got stronger and wanted to exert my independence, Kate's scorecard became too heavily weighted in the giving column. Suddenly she said she felt

used, that I was unappreciative of all she had done over those difficult months. Although we continued to live together, she basically ended our friendship.

I remember feeling terrible at the time. I wanted to thank her for all she had done, so I ordered a gift to be delivered to her office. She called to tell me she couldn't accept it and that she would return it to me. I said she could give it away, but that I didn't want it back. It was as though there was no way I could repay the karmic debt that I had incurred. And that was about the last conversation I had with her for many months. She ignored me at home and would barely speak to me when she saw me outside the house. I could never figure out what I had done wrong, but I knew I had to move out of her house.

Kate later told me she was devastated when she came home one day and saw my moving boxes lining the walls. She was unaware I was looking for another place to live, and the finality of it jolted her into putting her feelings on paper. Her letter basically said she had felt used, that she'd given so much. When I found strength and began living my own life, she felt I had abandoned her. She said she was praying that her heart would be softened, and that she would some-how be able to forgive me for my behavior.

I saw it completely differently. I began to realize that at least some of Kate's giving came at a very high price. I tried to explain to her that she'd given more than I'd ever actually asked for, and in so doing had excessive expecta-tions of what would be returned. Despite our different opinions, we rekindled our friendship somewhat. She was involved in my wedding, helped my husband and me move into our new apartment, and phoned occasionally.

That was about a decade ago. But it's only been recently that the mystery of this girlfriend has begun to unravel for me. Looking back, I see that Kate nurtured me more than my own mother did. She provided the warm home I never had. She helped me discover myself. She was a light at dark times in my life. And for all her gifts to me, I am thankful. But I've come to realize that friendships sometimes need to be adjusted. A true friendship is not one that tries to control or persist or persuade. And a friendship that does must eventually be pulled away from the heart, analyzed carefully, and gently placed at a distance to become a wonderful asset, but not part of the core.

My own personal journey with friendship continues to evolve. Because I'm now aware of my own emotional needs, I'm more careful about those I let inside. More than ever, I rely on friends who honor their relationship with me, who care for me, and care for themselves. I now believe we can only begin to honor each other when we learn to honor ourselves. And that, for me, is the beginning of true friendship.

Recognizing a controlling relationship early on is crucial. Signs to look out for include always feeling bad when you interact with the person, feeling that you disappoint them, feeling uncomfortable with what you want to do, and altering your behavior to comply with the wishes of the other person. Any relationship that affects your self-esteem in a negative way should be challenged. Even if a friend is "right," manipulation and control are never healthy. Such relationships diminish us rather than empower us. Staying true to yourself by honoring your own feelings and beliefs is your best protection against

becoming involved in a controlling relationship. We all have the right to our own view of life and our choice on how to live that life. Relationships that interfere with our own natural process lead us away from ourselves. Healthy friendships lead us toward our true path and strengthen our sense of self.

jealousy

Jealousy, the green-eyed monster that makes for such interesting stories in books and movies, can be another form of conflict with girlfriends. Jealousy was not reported as having been experienced by the majority of women surveyed. Yet in my clinical practice, I see the exact opposite. At first I was surprised at the survey results, but as I thought about it more, I realized that usually I'm the one who points to jealousy as an underlying dynamic between women. My clients themselves often report their stories with no realization that jealousy could be the underlying factor in why a friend acted in a hurtful way.

I used to see a client in her twenties who was extremely talented and attractive. As she reported her confusion about several of her female interactions, it became clear to me that these other women were jealous of her and lashed out at her because of it. Until that point, she was sure that she had "done something" to provoke them, but she could never figure out what it was. What further complicated her perception of the situation was that she had no appreciation of her own beauty or talent. In fact, she thought she was neither talented nor beautiful. As she began to consider that jealousy might be a factor, situations made more sense.

She no longer felt confused or "crazy." Eventually, she realized that she did have certain gifts that might instill jealousy in certain insecure friends. This allowed her to see situations more clearly and to deal with them more constructively. It also allowed her to select friends who really cared about her and let go of others that continued to be tainted by this jealousy reaction.

> **when i was** in junior high school, I was close with two girls in my class. We were close outside of the classroom too. We had a lot in common and did a lot together. For no reason at all, the two of them wrote me a letter stating they felt I was interfering with their friendship and did not want to hang around with me anymore. We had all been friends for over two years. I was crushed. I had never done anything to either of them. One of the girls moved away shortly afterward and the other girl and I became close again. I think the girl who moved away was the instigator. She must have been jealous of me—why, I still don't know. To this day the situation hurts when I think about it. I still have the letter packed away.

Jealousy can be so far beneath the surface that none of those involved are completely aware of it. Sometimes, one can manifest one's own feelings of jealousy toward another as irritation. I've had clients talk about women in their office who just "get to them." Later, it comes out that this person is more attractive or more accomplished or has done something my client has been unable to do. Recognizing one's own jealousy is also freeing, because the people we are jealous of can often be our teachers.

about fourteen years ago, my husband and I became friends with another couple who lived next door to us. One night we all went out to dinner for my birthday, and she became angry and jealous because her husband made comments about how I worked and still got the housecleaning done and she didn't. Then I danced with her husband, and she hit the roof! After that, we were never again close friends. I kind of kept my distance from them until they moved, and I haven't heard from her since.

I have experienced both sides of jealousy in powerful ways in my own life, and as I came to pinpoint this dynamic, my relationships became more comfortable. As a young woman, one of the girls with whom I had studied acting in New York became very famous as a movie actress. It drove me crazy. It seemed unfair and wrong, because I thought she was less talented than I was, and not a very nice person. The more successful she became, the less happy I was with myself. I would measure my accomplishments against her success, and invariably I came up short.

It took me years to work through those feelings. Before I could deal with them, I had to identify the jealousy. At first it felt like anger. "She didn't deserve it," I originally thought. But when I assessed my feelings with bare honesty, I was forced to admit the simple truth: I was jealous. I had wanted to be a successful actress, and I felt like a failure because I hadn't achieved the success that she had. It took a positive appraisal of my life and a fair appreciation of my own accomplishments to alleviate those jealous feelings. Jealousy is often a low self-esteem issue, and once that is dealt with, the jealousy subsides.

i think there is a lot of vying for attention between women, both with men and with careers. We all act as if there's not enough room at the top, and we all try to pull each other down. We don't compete with the men; instead we fight with each other to get that last empty space. We need to be supporting each other, but I know that I experience jealousy too.

I have also experienced the other side of jealousy. In my younger days, I had no idea why certain women were mean to me. In my naiveté, I tried harder and harder to "make them like me." Finally, I realized that I wasn't doing anything wrong. The problem lay with these women, who were jealous of my happiness. My life appeared ideal to them, and they resented it. Recognizing why they treated me badly set me free. I stopped trying to be their friend and moved on.

Jealousy is like carbon monoxide; they are both extremely difficult to detect. Whereas the poisonous gas is lethal to humans, jealousy is the silent killer of trust in friendship. It's important to remember that envy could be a major contributing factor in a failing or confusing relationship. It is crucial to be aware of the many guises of jealousy that may affect our friendships.

A majority of the interviewed women asserted that they had not experienced jealousy as adults. For those who did report these feelings, the predominant reason was lack of attention from a friend. Men were the next most reported reason for jealousy, followed by money, social status, and job position. Women most often reported their first jealousy experience at the age of twelve. Puberty is the time when most of us start liking boys. Historically,

women needed to mate with men to survive. Other females, then, would be considered natural competitors. Jealousy becomes a side effect of competition.

signs of jealousy

here are some indications of jealousy to keep an eye out for:

In you
1. You experience a sick feeling when you hear about her latest success.
2. You constantly measure yourself against her.
3. You tend to be judgmental and criticize her harshly.
4. You experience a sense of low self esteem when around her.

In her
1. She often makes unpleasant or critical comments about you.
2. She inspires guilt when you report successes.
3. She's judgmental, not only of you, but the other significant people in your life.
4. She discourages you from expressing yourself fully.

competition

Sixty percent of the women surveyed agreed with the statement "most females regularly compete with one another." Ironically,

60 percent also said *they* personally had never felt competitive with a female friend as an adult. It seems that we consider ourselves a competitive gender, but we do not see it in ourselves. This concurs with my clinical experience with clients who, at the onset of therapy, rarely recognize the competitive aspect of their stories.

When asked how they feel when a powerful, attractive woman enters a room, only 12 percent of our survey respondents reported feeling competitive. In terms of when competition starts, age twelve was the most reported age for first feeling competitive with another female. The least competitive were the older respondents, particularly those in the sixty- to sixty-four-year-old age range. Ninety-two percent said they did not hesitate to socialize with friends more attractive than themselves.

one of my friends was so competitive that I had to be second all the time to keep her happy. If we walked into a room, she had to get all the attention, all the time. I couldn't take it after a while. Eventually the friendship died.

One of the most interesting findings of my research was this perception of competitiveness among females. While acknowledging that most females compete regularly, most respondents said they have never felt competitive. More research is necessary to better understand these results. Do women feel only that their friends compete with them? Or do they believe it happens only outside their circle of friends? What do women compete for

when they compete? Do they believe it is okay to compete with each other? Are they oblivious to their competitive feelings, or are they just unwilling to admit them?

a ballet company is a very tight-knit, emotionally complex group of athletic artists. In the United States, classical ballet is considered an effeminate art form. Women make up a large part of the audience, but more important, they also make up a large part of the actual dance world. Therefore, extreme competition is ever-present in all of its vicious, loathsome forms, and that takes its toll on female friendships. I remember a male friend of mine telling me once that women ballet dancers just can't be friends. At the time I didn't believe him—but after thirteen years of being in this indus-try, six of them professional, I most certainly agree with him now. The only close female friend of mine in the ballet company I am with is about three and a half inches taller than me, which is probably the only reason we have stayed friends for so long. We are not eli-gible for any of the same parts.

Since the male gender is raised to compete, most men gen-erally accept it as a part of life. However, many women, partic-ularly before the women's movement, did not typically experience the natural competition that occurs in sports or in the work-place. When we conducted our survey and asked questions about competition, most women assumed that I was talking about competing with women for a man. They never mentioned work or sports.

My experience as a woman and as a therapist seems to contradict these findings. I watch and listen to women who compete in both the workplace and social settings all the time. But few admit to it or even identify it as competitive. In my experience, if you add a powerful, attractive woman to any group, she will prompt a strong reaction from the other women. Part of that reaction will invariably be competition. Like jealousy, competition can be subtle and sometimes difficult to identify as such. In contrast, my male clients expect competition, admit to it freely, and are actually motivated by it.

men

The impact of romantic relationships on our friendships can be huge. It makes sense that intimate and deep friendships between women would be greatly affected by the appearance of a love interest. It often starts on the playground in about sixth grade, when suddenly you stop talking to your best friend and flash a smile at one of the boys. Suddenly, men have arrived in your life. What we do with this phenomenon of "liking boys" progresses throughout our lives. More than 68 percent of women surveyed admitted that as an adult they have put a man before a woman friend. Seventy-five percent said it was wrong to forsake a friend for a date, but 40 percent have done it.

Many clients have spoken to me about the regret they feel over their behavior with girlfriends. Many of them have said that the men came and went, and they missed their former friends. I encourage them to reconnect, to make amends, to apologize. It is easy to get lost when big changes in our lives

when i was seventeen, my best friend since childhood became jealous when I started dating this guy (now my husband). He was outside of our then circle of friends. She wouldn't go out with us as friends even though she always had a boyfriend. The friendship between us ended. We only see each other rarely in passing and only say "Hi, how's the family?"

occur. If the friendship was strong and the behavior not intentionally destructive, the friendship may well be rekindled. If it can't be, you need to forgive yourself, learn from it, and move forward with more tools in place for the next such occurrence.

Why women put men first is open for speculation. For those of us raised to believe we needed a man to support us, this behavior is fairly easy to predict. If your life literally depends on a man, you will put him before anyone else. I do see a difference in my younger clients who have always thought they would be able to work and support themselves. There is much less desperation with regard to men. This is not to imply that they care less; they just panic less.

Almost 75 percent of surveyed women disagreed with the statement that "it is okay to break a date with female friend for a date with a man." As a young adult, I always considered a date more important than a plan with a girlfriend. We didn't even need to lie to each other about it. It was understood and acceptable. Today, I would try never to do that to a friend. Now, I recognize the value of my circle of girlfriends. For me, it is unacceptable to cancel plans at the last minute because of a man. Such acts are capable of affecting a friendship in a negative way.

on my graduation day I had previously planned to go out with my girlfriend to party, but I broke the engagement to go out with my boyfriend instead. My friend felt so rejected and hurt, she broke off the friendship for years.

Standards of acceptable behavior, however, do vary among friends. Each of us must identify our personal comfort zone and share it with our friends. In our survey, women listed disagreement about social plans as their primary source of conflict with their girlfriends. Considering how much we depend on one another throughout our lives, it's imperative that we treat our female relationships with the utmost respect.

staying connected with friends when you're in love

if you have been single for a while, it's difficult not to totally lose yourself in a new romantic partner. It is certainly a test of true friendship. A good friend doesn't deliberately abandon her friends, although she may do so without realizing that she is doing so. Friends sometimes fear abandonment when a new love interest enters the picture. Perhaps to them it seems as though the emphasis on their friendship shifts to the new relationship. It's important to reassure your girlfriends how much you value their presence in your life. It's equally important to balance your enthusiasm for your new love with continued interest your friends' lives.

change in marital and family status

Of the 1,052 women surveyed, 68 percent were married, 18 percent single, 11 percent separated or divorced, and 3 percent widowed. A majority of these women reported that they felt comfortable with their friends' spouses. Married women reported that they did not have more friends when they were single and that their friends did not change when they got married. In addition, these women overwhelmingly reported being supported by their friends as they made the transition to motherhood.

In my practice, I hear many stories of women feeling isolated soon after they marry. Whereas the connection with their friends remains, the nature of their contact may change dramatically. Suddenly a weekend is filled with couple activities that single friends aren't interested in sharing or would not necessarily be invited to. Children may also initially create this same feeling of alienation. Suddenly diapers and formulas are the new topic of conversation with old friends, who have limited exposure or perhaps even interest in such things.

i just got married and I'm having a hard time. All of my girlfriends are single. I feel different from them now and left out of the gang. I'm glad I'm married but I really miss my friends.

Women who are able to express their feelings of isolation and frustration can change them. If a friend is unwilling to address the issues, it may be time to reconsider the relationship.

Friendships of convenience do not hold up well during major transitions, while friendships of choice, which are based on love and respect, can survive enormous upheaval. Communication is the key. "I feel" statements can be incredibly helpful. "I feel left out when you all go out dancing instead of coming over to watch a video with Mike and me." Many women in our survey found that these transitions tend to smooth out over time. During the first months of new marriage or motherhood, we must be particularly sensitive to a friend in transition. Although deep friendships are resilient, they need to be nourished. A simple conversation can be a friend saver.

In terms of the effect of motherhood on long-term friendships, there was almost an even split between those who reported it did not affect their long-term friendships and those who felt it did. Most women agreed, however, that relationships with other couples did not provide the same depth as female friendships. The intimacy they achieved with true girlfriends was not duplicated with other married couples.

From our research, it's clear that a change in marital status does not necessarily alter women's commitments to their friendships. They have just as many friends after they marry, and many former friends remain. Most women indicated that their spouses integrate comfortably with their circle of girlfriends.

Repeatedly, women report the need for each other and friendships that are deep, important, and solid enough to withstand the major transitions in life. In a study on loneliness, Pearl Dykstra found that loneliness is commonly associated with being old and without a partner. However, the absence of friendship rather than being single is the most important factor in loneliness. Another interesting study published in the *International Journal of Woman's Studies* argues that contemporary women are

discovering that marriage does not necessarily lead to happiness. Therefore, skills at making friends are important. Having warm friendships may even stop single women from rushing into marriages that could be unsatisfactory or even harmful to them.

from as far back as I can remember I always wanted to get married. Soon after high school, I met a guy who seemed perfect for me. After a year of dating, we got married. Unfortunately, the three years of our marriage were miserable, and finally I got the courage to file for divorce. Older and wiser, I no longer had that overwhelming *need* to be married, but I did keep my radar engaged. In the years following the divorce, I met a group of women who became best friends. We jokingly called ourselves the "No Sex in the Suburbs" gang. These friendships kept me from getting lonely, because we did so much together. The only thing lacking was sex, and I had already found out from my first husband that sex wasn't all that mattered. I swear that if it hadn't been for my girl-friends, I probably would have remarried right away, and I believe that might have been a big mistake.

conflict resolution

When you have a conflict with a friend, it need not be viewed as something necessarily negative. It can be thought of as an opportunity to further understand the dynamics of the friendship. How often you have these conflicts with a particular

friend and how serious the nature of the conflict is can determine the best action for you to take. The first step in resolving conflict is accepting that confrontation is a necessary part of human relationships. It seems that women especially hate to confront each other. When we are willing to speak from our hearts that we are uncomfortable or distressed in a relationship, we can then begin to heal it. People disappoint and disagree with each other. It happens every day in most relationships. It's important to practice the skills of conflict resolution whenever a problem arises.

Trusting your friends with the true nature of your feelings will either bring you closer to them or will cause you to evaluate the health of the friendship. In a true friendship, when we verbalize our hurt and are responded to with grace, unpleasant feelings and tensions dissipate. In an unhealthy friendship, problems keep arising, and even talking about them does not lead to reconciliation. Perhaps your values are too different, or character issues have come into play. Confrontation can be the first step in clarifying the validity of a friendship.

I believe that people need to learn *how* to confront each other, because life requires it of us. Most of us don't like it, but learning how to confront each other while remaining calm and clear is a necessary tool for living. A relationship that is worth having is worth fighting for. Likewise, a destructive friendship most definitely needs to be challenged. So many times people fail to articulate their true feelings about a situation, resulting in relationships that never feel right again. The sooner we confront a difficult situation with our girlfriends, the easier it is to resolve the issues. And if the friendship is destined to be destructive, the sooner it can be eliminated the better.

a woman i met when she was thirty-nine years old and I was thirty-eight years old became my best friend ever, for the eighteen months she lived near me. When she moved away, I had just delivered my third child and she was very hurt and upset that I didn't throw them a going-away party. She also had financial problems and confessed that she was envious of our good fortune and lifestyle. The day she moved we argued over the phone and hung up on each other. I wanted to fly down the street and hug her and apologize, but I felt she was assuming too much at that time. I also can't say goodbye very well. Two weeks after she left, I called her. When she answered the phone, I said "Wanna go for round two?" She laughed and we talked for an hour. She lives in Kansas now and I go and spend four days with her, her sister, and our other friend once a year. We are like family and I treasure her so.

It is imperative to express our honest feelings regardless of the consequences. Equally important to remember is that feelings are not facts. They are colored by our current situation and conditioned by the map of our past. At the same time, your girlfriend is interpreting the same situation through the filter of *her* life experiences. She may have a completely different set of responses to a situation. Discussing your honest feelings and appreciating hers are the quickest ways to work through a conflict.

when i found out my friend was having an affair, she lied to me when I confronted her and then wanted me to help her carry it out. It was a bad time for us, but we made it through and I feel closer to her now than before. Although I did not help her, I did learn to put aside my personal feelings and stop playing therapist. She ended the affair and stayed with her husband. I never realized how important she was to me until we were not speaking to each other anymore. We have both learned that we all make mistakes but a true friend's love is unconditional.

This does not mean that you require the other person to agree with you. You are simply asking for them to respect how you feel about the situation. It's okay to agree to disagree with a close friend. Sometimes, that is the only resolution possible. Letting someone know how you feel gives them the opportunity to explain or defend their actions and to give their perspective of the situation. So often there is a genuine miscommunication that has led to the problematic occurrence. The words "I'm sorry" go a long way in healing. Learning to forgive that which is forgivable to you is an essential part of having lifelong friendships.

When your completed girlogram has clarified which friendships are life-enhancing, you will know that these are the ones worth fighting for. It is helpful to carefully evaluate your friendships to determine whether there is anything that is compromising the quality of the relationship. Sometimes people store hurt feelings or complaints, a practice that can drive a wedge between them and those they love. By approaching a friend

that you are upset with and simply stating your point of view, you extend to her the courtesy of your unique perspective of the situation. Even if the other person is unable to tell the truth about her feelings, your expressing your own will change tension between you. The more quickly you communicate your displeasure, or simple unhappiness, the more likely that resolution can occur. You spare further damage to the friendship.

Some friendships fall victim to small body punches. Nothing major; just seemingly insignificant gestures that leave you feeling irritated again and again. Listen closely to the inner voice that is giving you constant feedback about how you feel. If this voice complains too often about a particular friend, even though the complaint may seem unworthy of making an "issue" of it, pause a moment to consider it. Perhaps it is time to nip it in the bud. Small, insignificant body punches can eventually accumulate over time, until finally there is little or nothing left of a friendship. Again, communication is key in these situations.

i had an argument with a friend over something I said about her child. We didn't speak to each other for nearly two years. All my attempts to apologize failed. I went up to her at our sons' graduation and told her congratulations. It finally broke the ice and the hurt started healing.

I have had many female clients go on and on about how angry they are with a friend. When asked, "Did you tell her about that?" they look at me with an incredulous expression and say, "Of course not." It is as though they have an inner monologue that

is completely different from their outer expression. Why do you shrink in the face of confrontation? If you have a friend who becomes unpleasant when you express yourself, you may have to question the validity of that friendship.

A true bond is built with the room to honor differences. By modeling the behavior of an open communication, you can transform many friendships. As my clients progress in their therapeutic work, their outer monologues come to match their inner feelings. They describe feeling lighter, freer, and less afraid to take a chance with trust. In therapy, hopefully, we learn that respect and kindness can be part of any disagreement. I teach clients to use "I feel" statements in emotionally charged situations. "I feel hurt" instead of "you hurt me" helps the listener not to react defensively, thus allowing her to hear your feelings. The therapeutic bond is based on trust and confidentiality. True friendship needs to be based on these same principles. The roots of friendship are nourished in this way.

my friend of eighteen years found a cobweb on a chandelier in my dining room. She was so elated that she found it necessary to call my sister-in-law and tell her about it. Maybe I should have been flattered that one small cobweb could cause such a stir, but I was very hurt that my closest friend did this to me. Our relationship was never the same.

While most women agree that communicating is the best possible way to resolve a conflict, many still take the "time heals all wounds" approach. Time does reduce the charge in a conflict.

With time, people tend to relax and become less emotionally invested in the conflict. Through my experience as a therapist, however, I have observed that women who are content to let time heal their conflicts never resume the quality of relationship they previously had. The wound never heals completely, and the ensuing friendship is compromised.

My girlfriend Eileen had a friend who called her often. Over time, unfortunately, her friend grew upset that Eileen was unavailable for many of these calls. When they would finally connect, this woman would voice her anger and frustration, which made Eileen feel guilty. At first, Eileen apologized and tried to placate her friend. But instead of resolving the situation, the dynamic grew stronger and more unpleasant. As so often happens in the face of difficult situations, Eileen initially chose to simply avoid the woman. Upon consideration, however, Eileen decided to talk to her friend face to face about the feelings of resentment she was experiencing. She explained how busy work was, and how most of her free time was spent boating with her husband. Eileen told her friend that although she welcomed her calls, she resented feeling obligated to continue the friendship on such demanding terms. Once her friend understood the situation, she no longer felt rejected by Eileen's delayed response. She accepted the parameters, and they have been friends now for more than a decade.

This example illustrates the value of communication. Both of these women let the other person know how they felt, each confronted the other person. They might have lost the chance for this friendship if each hadn't addressed the situation and dealt with it in a face-to-face manner.

a friend of mine, whom I had been close with for fifteen years, came up to my apartment one night after work with a male friend. She introduced us and we all visited for a couple of hours. A week later, this man called and asked me out. I told him I would [go] only if there was nothing going on between him and my friend. She had told me she was in love with him. He said he talked to her and told her they would only be friends, nothing more. He and I were watching a movie one night and my girlfriend stopped by. Apparently, he [had] never talked to her. After much crying, screaming, and name calling, things have settled down. It took us four months, but we were able to patch up our friendship and it's as great as ever.

how and when to address conflict

1. Address your concerns calmly and as quickly as possible.
2. Start your sentences with "I feel . . ."
3. Listen. Breathe. Go slowly.
4. Consider the other person's response. Treat the other person with respect.
5. There's no need to attack or defend. Stay in your truth.
6. Even if the other person denies your reality, honor your feelings.
7. Don't expect resolution. Sometimes, you must settle for clarity.

triumph over conflict

Sometimes, even in the face of potential conflicts such as jealousy, competition, men, and marital status, a friendship can flourish. As a single woman, I have felt both the pleasure and difficulty of relating to married women. Sometimes I would have a male colleague and be disappointed upon meeting his girlfriend or wife, because she was distant and unwelcoming. It seemed that no matter how hard I tried, she mistook me for a threat to their relationship. An exception to that is one of my best friends, Lyndie.

my best experience with a female friend was in the army. We got into a huge fight and she left crying and I got into my bed crying. She turned around in the middle of the highway and came back to my room. We said we loved each other; we'd just agree to disagree. This was the day she surpassed the barriers of friendship and became a sister. That was ten years ago. We haven't said a word about that fight since. We remember when we made up, but couldn't tell you what the fight was about.

In Georgetown, our local morning coffee shop is called the Booeymonger. For years, I would observe a neighbor ordering two cups of coffee and walking back to his home. Eventually I learned his name was Curt, and I would tease him about how lucky his wife must be to have coffee everyday in bed. This went on for years, and I never saw them together.

One night, a local restaurant owner, Shahab of the Peacock Café, held an engagement party for himself and his lovely fiancé, Mickey. Just moments after I walked in, I saw Curt, who immediately came over and complimented me on my little black dress. As I thanked him, I saw he had left a woman, who I assumed was his wife, at a table nearby. She surprised me completely by beckoning to me and then insisting I join them at their table. Her warmth and beauty overwhelmed me. Here was a woman led by her heart, not her fear. We had a delightful evening, and the next morning I was pleasantly surprised by a beautiful book Lyndie left at the Center for me. It was the first of a thousand thoughtful surprises I would receive from her over coming years.

Recently, when I decided to live in Florida, it was Lyndie and Curt who made the commuting possible. Each month I arrive in Washington, suitcase in hand, and proceed up the stairs to their cozy guest room. Curt refers to me as "the phantom guest," as I slip in and out of the house for appointments with clients and meetings with friends. One of my most cherished evenings each month is sitting around the kitchen with Curt and Lyndie as she prepares a gourmet feast for the three of us.

Curt's favorite story about my friendship with his wife is that Lyndie comes from three generations of women who do not cook. I doubt that she even knew if her oven was gas or electric. After many years and tens of thousands of dollars spent on meals at local restaurants, Curt implored me to teach his wife to cook. We began a weekly ritual called "Terrific Tuesdays," when I would come over and teach Lyndie a new recipe. Now Lyndie has far surpassed her teacher, and she continually surprises Curt and me with new and fabulous dishes each time I come to town. Curt never fails to thank me for all the money he saves.

In our years of friendship, Lyndie and I have never experienced a moment of conflict or tension. With her strong faith, she has been a beacon of guidance for me in so many situations. Lyndie takes care of everyone in her circle of love with exquisite care. At Christmas time, their home becomes Santa's workshop, as she wraps and ships presents to needy souls around the world. She always sees the best in another person and never turns her back when a need arises. Lyndie was a kindergarten teacher for thirty years, and now all of her friends feel like her students, as she continually teaches us about the pure spirit of friendship.

Lyndie has made me a better person and taught me how to be a better friend. She reminds me that former problems I had experienced with "the wives" had more to do with them, perhaps, than with me. And she illustrates what a precious treasure we possess when we are fortunate enough to find a true girlfriend.

how to say goodbye

There certainly are friendships that need to be ended, but an abrupt ending to a relationship can be a sad and painful experience and a big loss to both people. Relationships that experience this type of "emotional cut-off" often leave us feeling unsettled and disoriented. If a friendship cannot be saved, closure is helpful, even if in a letter, to help us reduce the emotional damage of the situation. My friendship with Sarah and its abrupt ending created a sense of loss that I still feel today. I tried through a mutual friend to initiate contact, but Sarah never chose to respond. I still believe, however, that leaving the door

open for reconciliation embraces the idea that people change and forgiveness is possible.

Sometimes the best line of action is to let go of the person and hold on to the good memories. Sarah's way of living at that time in her life felt dangerous to my well-being. I still believe she could have damaged me had I continued the friendship. In my heart I wished her well, but I accepted the fact that not all relationships are meant to go on forever.

diana and i had been friends for over seven years. We had dinner together at least twice a week and watched our favorite sitcoms at each other's apartment. On weekends we did antiquing and often went out clubbing together. Then one day Diana did something that really hurt me. I won't even try to explain what she did, because it would seem not that big a deal. But to me it showed a major flaw in her character that I could not deal with, and it made me stop to evaluate other times that she had hurt me. After our big fight, everyone thought that we would make up after a couple of days. But during those days, I decided that the fun and companionship that Diana brought to me was not worth the hurt that came with it. I made a conscious decision to no longer consider her a close friend. This gave me more time to build new and different relationships. My only regret is that our last words together were spoken in anger, but maybe that was the only way to make the break.

If it is not possible to work through a conflict with the other person, if you feel compelled to say goodbye, try working through the details with your other friends. They can help you process, clarify, and resolve your part of the conflict.

According to our survey, more than 90 percent of all respondents felt it was important to resolve a major disappointment or dispute with their female friends. More than 75 percent said they had been successful at working through a major disappointment.

Girlfriend therapy

1. Are any of your friendships plagued with conflict?

2. Note your friendships that have been troubled with control, jealousy, or competition issues. Have they been resolved?

3. How do you resolve conflicts? How do your friends resolve conflicts?

4. How have your romantic relationships influenced your friendships?

5. How has marriage/and or a family influenced your friendships?

6. Using your girlogram and the lists you have created through the previous Girlfriend Therapy exercises, determine whether you should redefine any of your friendships.

7. If you discover friendships that you need to add some distance to, move their names to the outside circle.

8. List any friends to whom you should say goodbye. What can you do to let go of these negative friendships with the least amount of hurt?

the "new girls' network" 5

OUR EXPERIENCES AS women broaden as each new decade shapes who we are and how we relate to one other. Our bonds have been strong throughout the ages, but the direction these bonds take us continues to evolve. Perhaps no decade has shaped us like the 1960s, when the women's movement first pushed women into a unique and liberating spotlight. Maybe we don't yet have the equivalent of an "old boys' network," but the power and force of women in the world continues to build. As we attempt to integrate our homes, our families, and the workplace, new challenges arise that can be worked through with the help of our girlfriends. As each woman chooses her own path and reaches out to help others, we contribute to a "new girls' network."

the women's movement

In my experience with clients as well as friends, a mention of the term "women's movement" provokes a wide range of responses, from very positive to extremely negative. Many women are not sure exactly what is meant by the term "women's movement." Depending on your age, and who you were with at the time, the impact of the sixties varies greatly from woman to woman. Although women had come together as a movement for political freedom long before the sixties, the term "women's movement" grew out of that decade.

I was a student at the University of Maryland in 1969. It was there I first learned about academic politics, freedom marches, gay rights, the oppression of African Americans, the frustration of white liberals, and male power. In this context, the women's movement was one arm of a rapidly emerging new force. Thinking of other women as sisters, instead of adversaries, and realizing our potential as a group, empowered me. The women's movement encouraged me to believe in my own dreams and in myself. The wild days of the sixties filtered down over the years into calmer times, but everything I learned then, I still believe in today.

i never understood women's lib. I mean, what is the big deal? I have just graduated from college, and to me there are no restrictions on my future. Everywhere I look there are successful women—in government, in medicine, everywhere. If you are a woman who wants to work hard, you will make it to the top. I've heard that women don't earn as much as men, but I just don't see it.

More than 60 percent of the women surveyed for this book said the women's movement is important to them, but 75 percent said *membership* in a women's group is not. Sixty-five percent did not consider themselves to be a feminist. I believe that many of the women who spurn the idea of being a feminist indeed enjoy the benefits of feminism. Their lives are a testament to the edicts of equality and freedom, which are the cornerstone of feminist thinking. It always strikes me when clients express this view that they would not have their current job if it hadn't been for the women who fought for equality. Young professionals do not know a world where women were denied opportunities in the workplace. Even those of us who were pioneers in this arena had no idea how far and how fast women would actually progress.

The women's movement was never meant to deny femininity, but rather to celebrate it. Women coming together to stand for equality has changed the course of history. "I like the idea of the women's movement, even if I don't think about it much," one survey respondent wrote. "If women hadn't come together, we wouldn't even be voting. I hope some sort of women's movement continues forever."

Another person wrote, "Respect for women is completely important to me in all my friendships. I consider myself a feminist and am not at all embarrassed by that label. If you want to be respected, you have to stand up for what you believe is right. I see discrimination all around me still, and the women's movement addresses that discrimination."

It will be interesting to see how the next generation defines and advances women's issues. My youngest clients expect nothing to stand in their way, and most feel that women can compete with men professionally, if not surpass them. Many of

i like the fact that women are talking about important subjects, such as abortion, and acting politically on their feelings. Also, as a fifty-year-old woman beginning menopause, I'm grateful that information from other women is available. Because women are becoming powerful in the world, more research about them is being published.

my clients in their thirties, as they take on ever-increasing responsibilities, seem to need a higher level of support from other women. Every generation has its own problems to sort out, and women's issues will continue to change as women themselves change the world.

Two studies further illustrate the dichotomy of beliefs about the women's movement. A study at the University of Oregon investigated whether changing life patterns and the women's movement had influenced women's feelings about personal relationships. The study found that feminist consciousness produced a sense of self-worth and integrity. Relationships with other women were found to be central in the structuring of their lives and great sources of support and affection. On the other hand, a study by Paula Caplan at the University of Toronto found that two reasons women gave for opposing the woman's movement were that advocating woman's rights "was unfeminine and that women will lose their privileged position." These women seemed terrified of the very premise feminists were struggling for—the equality between genders and the freedom for women to choose the direction of their lives.

building a network of women's groups

In my experience, while women tend to avoid formal groups, they do gather in more casual settings. While women of today may not schedule the weekly card parties of my mother's generation, we do join fitness clubs and take classes together. Women go to local tea and coffee shops to chat (and knit!) together. We join meditation classes and book clubs, babysitting co-ops, playgroups for our children, art workshops, and myriad other interest groups— all of which connects us with other women. At the very heart of these informal gatherings, the values of the women's movement are being advanced.

Feminism began with women's suffrage, which won us the right to vote. By the sixties, a culture of young women decided things should be even fairer in the world. They believed there should also be social and economic equality between the sexes, and that *everyone* should share equal rights. This expanding women's movement was but one small part of a sea change that occurred in the sixties and seventies.

Young women of today, who perhaps never experienced that level of sexism, may take equality and opportunity for granted, as this is normal for them. However, even they must be affected by the pervasive sexism that still exists today. It rests with them to continue the process and build on the successes of previous generations of pioneers.

"Seven of my friends formed a women's group a few years ago," one respondent wrote. "We were all going through hard times, so we called it 'WOE' for 'Women On the Edge.' We all listed our goals, and every week we set out to accomplish something toward these goals. We all shared ideas and suggestions

and helped each other reach these goals. Everybody reached at least some of their goals. It was tremendous."

Years ago, I began a woman's group in Malibu, California. I was the therapist, and I provided the space, but the women defined and ran the group at each weekly meeting. I observed everything that took place and occasionally participated verbally. Through the stories of these women, I watched as lives changed and emergencies and victories passed. I saw family dynamics reenacted and old fears confronted. I was especially struck by how age differences affected who women thought they could be.

i'm different in my women's group. I'm an extrovert in there. I'm also really funny—it's like this whole great sense of humor emerges. In the rest of my life, I'm rather quiet. I like the person I am in the group—she's more fun.

Years later, I spoke with one of the women who attended these weekly sessions, and she talked about the richness of the friendships she had formed while in this group. She ran into some of these women occasionally and said they all felt like sisters, even if they hadn't seen each other in years. I know I will never forget any of these women. It was such an amazing experience to watch women grow in each other's presence. In Washington, D.C., I organized another group of unforgettable women who came together every week to share their stories and their dreams. Once again, the power of the group was overwhelming. Each woman learned so much about the others and so much about herself.

I believe such groups could be a beneficial experience for young girls. I advocate that one of their many after-school activities be replaced by a girls' group, where they could simply talk about their feelings. A twelve-year-old client of mine told me how it changed everything for her when her teacher

when i was sixteen and having the usual problems at school, my mother made me join a group of girls that she and her friends had put together. I guess the mothers had gotten together and decided to save their teenage daughters by forming this group. Of course I hated it (at first). I wasn't really friends with any of the other girls—only one of them was in any of my classes. We were just supposed to talk about what problems we were having at school, and at first no one wanted to say anything. I mean, I wasn't about to tell these girls any of my secrets, and certainly not in front of one of the mothers. After a couple times, though, I started feeling more comfortable with the group, and as the other girls started opening up, so did I. We talked about everything: boys, the snobby cheerleaders, teachers, being grounded. I felt so connected with these girls after a while that we became friends. I think the group helped us all get through a tough year. As usual, other things became pressing, and the group slowly disbanded. But I will forever be grateful to my mother for making me do this. Some of those girls are still my friends, eleven years later.

held a girls' group at her school. In this group setting, my client told the girls in her class how much it hurt when she had

not been invited to a birthday party. The other girls felt bad and promised to not exclude her. As they got to know her better, they realized that she seemed different because she was, in fact, extremely intelligent. I believe the group experience changed the course of all of their lives.

This was one little group, held one time, by one teacher. As a clinician, I deal with people's lives on a one-to-one basis. Each life is important. If a group can help only one little girl, it is a success. That one girl could be your daughter. She could be you. In each of the groups I have been involved with, the women appear to learn and grow and connect with each other in new and different ways. In some cases, a group can even save a life.

building a network in the workplace

The subject of women in the workplace is heavily influenced by the fact that men still hold much of the power in the workforce. In response to the question, "Has a female friend ever helped you get a job?" the majority said "No." The easiest way to help someone get a job is to own a company or run a division of one. This may be why some of these women had never been helped by a woman in a job search. The good news is that about 40 percent *have* been helped, and that occurred most often between the ages of twenty-one and twenty-nine. It could be that younger women are feeling, and indeed *are*, more powerful, and they are, therefore, more able to share power with other women. I observe a very different attitude about the workplace in my twenty- to forty-year-old clients, compared to those over forty. The younger women expect to compete with their male counterparts, and they expect

to win. They were raised in an era when being a white male was not necessarily a prerequisite for success. They work hard and expect to be rewarded well.

Twenty years ago, when I entered the workplace, I was grateful that men even allowed me to be there. Women always sat behind the desks in outer offices. Men were inside the offices. During the last two decades, it often seemed to me that when a woman broke through the glass partition, she didn't necessarily want other women there with her. Remember, this was early in the women's movement, when a lot of women nearing the top acted, and even dressed, like men. These were the first women to arrive, and they might well have aligned more with the men around them than the women who worked for them. This attitude may be reflected in the negative response women give in terms of working for other women.

Power may come into play here, as well. The more powerful the person you work for, the more likely you are to get ahead. If men are still most often on top in the workplace, with woman still striving to get there, working for a man might still be the fastest way up the ladder.

But that doesn't mean it's the most rewarding way up the ladder. Building a network in the workplace starts with the idea that collaboration, not competition, leads to a healthy and productive work environment. Many women spend a majority of their time in the office, and we need that time to feel safe and comfortable. Reaching out to younger or more experienced colleagues will create relationships that greatly influence the workplace. Women generally set the tone of the office, and believing in the sisterhood of gender can transform the dynamics of an office environment. Even the most difficult colleague will eventually respond to an outpouring of kindness. Each of us has the

power to lead the way, and leading with love is always its own reward.

tips on building a "new girls' network"

1. Set aside feelings of insecurity, competition, and jealousy. Try to open your heart to your female coworkers.
2. Adopt an attitude of positivism and responsiveness.
3. Be professional. Keep your attention focused on your work, and set an example.
4. Ask for help when you need it. Assume teamwork is the office policy.
5. Don't gossip or speak with disrespect about coworkers. Know that one great influence can transform an office.

friendship in the workplace

In our study, friendship in the workplace brought an affirming view of women's relationships. A majority of respondents said that their favorite people to work *with* were women. Office friendships have proven to be important to most women, and over 60 percent said that friendships continued on even if their working relationship ended. Typically, women do not separate their work friendships or regard them as less important than their friendships outside of work. Throughout the interview process, I heard women repeatedly assert that workplace friendships are important, trustworthy, and valuable.

I worked for a woman who was my best friend. After a while, the better I did at my job, the tenser the relationship got. She began to compete with me on everything. It got so bad I had to leave my job. I tried to remain friends, but the competition was always in the way. We still send Christmas cards, but that's all.

"I work mostly with females," said one of my clients. "I have found that women speak much more candidly than men do. I value my friendships with my coworkers. I can say exactly what's on my mind with little threat of being judged. I have found that my coworkers and I can participate in group discussions and even enjoy differences of opinion. Men, on the other hand, grow uninterested in the conversation when others don't share their opinions. My best experiences with female friends are my daily interactions with them at work. I consider myself lucky to be in such a supportive working environment!"

emotions and power

More than 60 percent of the women surveyed disagreed to some degree with the statement, "Women are better to work for than men." The reason that certain women are difficult to work for may be linked to the fact that we are still getting used to this position of power. It takes time for most people to build the confidence required to delegate to their subordinates. The skills necessary to guide and lead people without creating resentment and competition are learned over time. As women progress in the workplace, and their managerial skills improve, gender will play less of a role in women's preference of employer.

"I worked for a female boss once and it turned into a nightmare," a client confided. "The better I did, the less she liked it. She became so convinced I'd get her job, she began to undermine me with the owners of the company. Finally, I resigned. I couldn't take the stress of being with her every day, and she refused to discuss the problem."

Judging from many of my clients' stories, women also struggle with inappropriate emotionalism in the workplace. Learning to be professional has not come easily for some women. Many described personalizing work situations and having emotional outbursts in the office. I also see clients in powerful positions who are uncomfortable confronting the people who work for them. Over time, this leads to a variety of problems for everyone involved.

If you are fortunate enough to be in a position of power in the workforce, you have a greater responsibility. You are defining the model of female managers. You are showing both the men and women in the workplace what a woman is capable of. Therefore, it's imperative that you set a good example. Women, as a gender, may indeed be more "emotional" than men, but this trait will be judged negatively on the job. When Geraldine Ferraro cried on national television, a nation deemed her too emotional for the position of president of the United States.

Don't take your personal life into your workspace. This will actually give you a break from your personal problems. It will also foster a healthier working environment. Personal calls at work tend to bring emotions to the surfaces that have no business on the job. Gossip certainly has no place at work, especially if you are in management. Women do love to talk, but it's important to refrain from gossip on the job. In short, women may have to

slightly alter their natural inclinations in order to curb their emotions on the job.

Alternatively, other women overcompensate in leadership positions, becoming dictatorial, aggressive, and adversarial. Perhaps this is directly related to the struggle women have encountered working their way to the top in a male-dominated workplace.

in my experience in the military I've found women to be ultra-competitive. They don't mentor. When they establish friendships it's never professional, always social. Work is seldom their number one priority. When work is involved, women don't help each other out. I value my professional relationships with the men I work with much more than my social relationships. Why is it that when women get together professionally it always follows that the relationships must also be social and that means gossip? Men seem to be able to develop professional associations that help each other and do not necessarily become socially involved. I think I may be atypical because I value my time alone. I usually get all the social interaction I need at work and when I go home I don't want to be gossiping on the phone (I despise telephones!) or sitting and talking. Got too much else to do!

I'm not insinuating that women are inept or not as good at their jobs as their male counterparts. Rather, I am suggesting that women have different issues and obstacles to overcome as they continue to advance professionally. Even motherhood, with its

authoritative position, has an impact on how women perceive their leadership role in the workplace.

Certainly, we have had fewer opportunities to observe models of successful female leadership in the course of our lives. The opportunity to observe women of power, however, is expanding exponentially with each passing year. There are more female chief executives and political leaders than at any time in our country's history. Women also have become entrepreneurs and business owners in great numbers. The more role models we have, the more skilled we will become in leadership positions. As a result, the "new girls' network" will grow stronger and be of value to more women.

i will always remember my first female boss, for she taught me how to run an office, just by her example. She was firm but kind at the same time. She was great at follow-up, and she made it clear that we were accountable for our assigned tasks. She did not sit down and have lunch with us, and we never saw her after work. She was our boss, and we all respected her. Now, as a female boss myself to both men and women in different parts of my job, I have patterned my style after my former employer. By her example, I've learned that you can't be a friend with your employees. You can be friendly and show interest, but you must stay mostly uninvolved.

balancing career and family

In recent history, women have become both home and career-centered, occupying an ever-growing place in the workforce. At the same time, we remain the primary caregivers for our families. Almost 50 percent of the women surveyed have a full-time job. Twenty percent work part time, and 6 percent are retired. As women have taken on the joint tasks of home life and career, new types of problems manifest themselves. Not only do working mothers struggle with child care and time management issues, but single women struggle as well. They speak to me about their resentment of being expected to be the last to leave the office, because they have no children. The reality is that both single and married women face a new challenge in balancing home responsibilities with burgeoning careers. It is a hard balance to strike, and certain jobs do not conform to the rigors of a child-care situation.

One of the leading causes of stress that I witness in young couples with children is division of labor. Who will get to work late, and who will meet the deadline at the babysitter's? Who will get to work one extra hour at the office, and who will take the kids to soccer practice? Snow days, sudden illness, and even planned school holidays can be a crisis situation for a two-income family. Without the luxury of nearby family, women often end up helping other women meet these trying situations. The best child-care arrangements often revolve around a good relationship between two women. Even though many of my female clients earn as much as or more than their husbands, child care still falls into their realm of responsibility. With this in mind, it

is actually quite amazing that women have come as far as they have in the workplace over the last several decades.

The following testimonials from women we spoke to illustrate some of the factors that must be considered in today's world:

"I am the boss in a crazy business where everything is needed yesterday," wrote my friend Eileen. "Changes in production are always happening at the last minute, and the postproduction facility has to make everything under budget and on time. When my twin sister decided she was ready to leave the suburbs and twelve years as a teacher in sweat pants in a nursery school, I offered to take her under my wing. My invitation was extended, however, with the following caveats: (1) You'll work crazy hours, and you can't leave just because it's six PM (2) We probably will never take vacations together. (3) You'll find I'm not the same sister you know at home. I wear a different hat at the office. You might not like the office me, because I'm strongly opinionated and adamant about how I want things done."

A survey respondent wrote, "When a woman makes a decision that she wants a career, she must realize she is making a really important choice. Essentially you are deciding to give priority to a job or profession, not to the home. This usually means not having children, unless you can afford help. I never had children. I never wanted the responsibility of doing so much and being so responsible. Instead, I chose a career, and to this very day, at fifty-two, I'm still happy about my decision. There was a time when my sixteen-year-old stepson lived with us, and he'd call me at work and ask 'what's for dinner?' I'd say, 'If you want it, then make

it, and clean up after yourself.' He understood and often made us all dinner."

Understanding that you will not always be able to be the star at the office and the queen of the home can help you accept the day-to-day challenges. If you can keep your sense of humor, enjoy the camaraderie of your girlfriends, and appreciate all that you accomplish, your life will feel rich and fulfilling.

Girlfriend therapy

1. Do you have friends at work?

2. Do you have your eye open to new friendships in the workplace? If not, why not?

3. With whom, among your colleagues, would you choose to become friends?

4. What feelings do you project at work about friendship, that is, are you approachable and inclusive, or do you seem aggressive, angry, and/or uninterested in friendship?

5. How do you get ahead at work? Are you strengthening the "new girls' network"? Are you honest and supportive of your coworkers, or are you manipulative and deceitful?

working the network

6

M Y SUCCESS IN the workplace was guided in many ways by my network of girlfriends. I had just moved to Washington, D.C., from Malibu, California, to pursue a romantic relationship that quickly fizzled. Six weeks after my arrival, I found myself bewildered, sad, and lonely. With nothing better to do, I attended an art gallery opening for single people on Valentine's Day. As I asked the bartender for a glass of chardonnay, a casual conversation began with the tall blonde woman standing beside me. She introduced herself as Maura and asked whom I had come with. When I told her I was alone, she immediately included me in her circle of friends. Within moments, we were happily chatting away, and I heard myself laugh for the first time in weeks.

I explained to Maura why I had come to Washington. She commented on how brave she thought I was to move my therapy practice across the country at age forty. She gave me her card and suggested I call her for lunch. Twelve hours later I was on the phone. She graciously took time from her busy schedule as a family doctor to see me. In one lunch, I found a new female dentist, lawyer, hairdresser, and someone who would come to be a new best friend and colleague. The "new girls' network" was indeed working for me.

Our friendship has continued for over a decade, and our bond continues to grow stronger with each passing year. We have referred patients to each other, worked on difficult cases together, and vacationed together. She also introduced me to another beautiful best friend, Johanna.

Maura helped me to move forward with one of the best investment opportunities of my life. I had the opportunity to buy a building near my office in Georgetown at a fair and reasonable price. Somehow, I couldn't imagine myself purchasing a building and turning it into my dream of having a holistic co-op. The risk seemed too great. I had to make a quick decision and called Maura. I said, "Maura, if I don't do this, it's because I lack courage." She simply replied, "Well, then, you have to do it." That was it! On the strength of those simple words and the huge faith implicit in them, I proceeded.

Today, at 3259 Prospect Street in Georgetown, stands a beautifully refurbished building. The Healing Arts Center of Georgetown is the home of ten happy practitioners, whose skills include massage, acupuncture, chiropractic, meditation, and psychology. In the bustling power city of Washington, D.C., the Center is an oasis of calm and healing. My dream has become a

reality, and it would not have happened without my friend Maura. Again and again, I witness the synergistic power of my network of friends.

It was no easy task to renovate a two-hundred-year-old building in six weeks with very little money. On the weekend before we were scheduled to open, many girlfriends came forward to lend a hand. My friend Sharon, who owned the Earth Star Connection, a metaphysical bookstore and candle shop, came by and revitalized the energy and brought a wonderful spirit and scent to the building. Maura and Johanna lent artwork and hung it, completing the Center's decor. Everyone had something to offer and a free hand to help.

Our opening party was a fun celebration. However, the first day I went to work, I felt strange and quite lonely. Suddenly, I had offices to fill, and Washington is hardly a mecca for holistic practitioners. I ran a small ad, offering office space, and I was discouraged by the first people who responded. They seemed more interested in my insurance policy than the facility and our mission. Then, in walked Meridith. Looking around, she said, "I already have two jobs in clinics, a husband, and a small child, but I am meant to be here. I can't start working here for several months, but I want to rent an office." I laughed and said, "You must be kidding!" She responded, "Not at all. This is my dream, too."

For almost five years, we have worked side by side. Meridith has shown me not only the greatness of friendship, but also the support a true colleague can offer. She has helped me make tough decisions and encouraged me to believe in new dreams for the Center and myself. Together, we have built the Center from just two of us to the bustling practice it is today. Thanks to the help

of my friends, the Center has become a beloved addition to our beautiful nation's capital. It's a great example of how "working the girlfriend network" can contribute to one's life.

the "new girls' network" in action

when i was in college, I wanted to apply for a congressional internship in Washington. I knew it would be a long shot because the only program I knew about was a very competitive one that took applicants from around the country. I mentioned this to my mother, and she told me about a family friend who worked for a U.S. senator from my home state. I contacted her, and she became my first professional mentor. She walked me through the application process and did everything she could to help me secure an internship on Capitol Hill. She also found me a place to live, introduced me to friends, and kept in close touch with me throughout my internship and ensuing career to help me succeed.

I was blessed that summer to meet many helpful, supportive women. Three of them became some of my best, lifelong friends. One of them was my immediate supervisor, the senator's assistant press secretary, who was my friend, mentor, and role model. When she decided to quit her job to go to law school, she paved the way for me to take over her job. If I have a female soul mate in this life, it's probably she. We share many of the same dreams, challenges, and philosophies about life. Even though we haven't lived in the same city (or even on the same coast) since that summer in 1979, we have remained best friends and always yearn for opportunities to write and work together and learn from each other.

The two other women in the office were the manager and legislative director. We met about twenty-five years ago and still remain best friends today. We have helped each other through many challenges, including one woman's fight with breast cancer, another's life-threatening illness, several deaths of loved ones, and many career and family transitions. These friendships have been a source of much joy, support, and love in my life, and I will always be grateful that we crossed paths and became lifelong friends. We started out as officemates but through shared interests and experiences, we have created lifetime bonds of friendship. Because we all had different types of jobs in the office, we didn't ever feel that we were competing with each other. This helped us support each other professionally. Our support and loyalty for each other laid the groundwork for solid and sustaining friendships.

Social Status and the New Girls' Network

Close to 50 percent of the women we surveyed said they felt more comfortable with friends of a similar income and educational level. However, if at some point their income rose significantly, it did not change their circle of friends. "Social status" itself is an interesting term to try to define for women. Is their status defined by their husbands' income, their own income, or a combination of the two? Is status concerned with only education and money, or does it include personal beauty, possessions, lifestyle, or professional achievement? Is it gender-related, or if

the woman is at a higher social status level, does the male move up, too?

women are so competitive about social status and at my social level it's so ridiculous. I've had it with women checking out everything I own and always trying to one up me. My mother never had much but she was always happy for her friends when they got something new. Only one of my current women friends is self-confident enough not to be threatened by possessions. When I find women friends are becoming status seekers, I usually distance myself from that friendship. I've tried to ignore it or compromise but I find it usually gets worse and worse. I find these relationships sad and disappointing.

Women who share a comparable education often have similar interests, incomes, and lifestyles. Women describe it as "being easier" to be a friend, when their lifestyles are comparable. Buying clothes, traveling, having jewelry, owning a special car or house can be difficult to enjoy with your best friend if she is struggling to put food on the table. Friendships can survive this type of disparity, but not without work, sensitivity, and compromise.

The influence of familiarity cannot be overstated. As a therapist, one of the things I have come to appreciate is how people are drawn to the familiar. The old joke is, "Yeah, this might be hell, but it's a familiar hell." This familiarity phenomenon can be frustrating to therapists as well as to their clients who cling to the familiar people, actions, and thoughts that are

destructive to them. This continues long after they intellectually grasp the need to make a change.

Research on why people are attracted to others also highlights the phenomenon of familiarity: proximity and exposure are main ingredients in attraction. Most of us hold on to the safety of that which is known and shared.

Another study, conducted by Judith Levy at the University of Illinois, found that as women returned to school after an extended time, they were likely to experience a cessation in some of their friendships. It was easier for these women to make new friends than to hold on to old ones. If former friends could not accept the limited time now available to them, the friendships did not survive. The old friendships that did survive were usually with women who were likewise experiencing a life change. Because their situations were similar, they felt familiar, and this familiarity heightened their bond.

One of my clients was given a tremendous promotion with a generous raise in salary. She was ecstatic when she first told me the great news. She had worked hard and long for this terrific job and was excited to tell all of her friends. She returned a week later, crestfallen, saying that no one seemed to share her joy at this new development. She suffered snide remarks about sacrificing the chance of having children in order to succeed in her career. Others implied that the reason she wasn't married was that she gave her soul to her job.

Her oldest friends back home seemed much more supportive, but her present circle was critical, and she felt they were downright mean. We began to construct a picture of who the new friends were, and why she had selected them. It turned out she hadn't selected them at all. They were actually friends of

convenience. Considering each of them, she made a decision about which ones to let go, and which to confront with her disappointment in their reaction to her promotion. She was relieved to find that the women she chose to speak with responded with understanding and an apology. She felt much closer to them than ever before.

I personally experienced a dramatic change in my circle of friends after my divorce. I was once married to the vice president of a major company in a relatively small town. We were socially prominent, and I had many new friends as a result of the marriage. For six years I dined, shopped, played tennis, and traveled with these women. At the time, I considered them to be good friends. After my divorce, I went back to school and suddenly lived a simple life as a student. I never heard from most of these women again. Today, only one of them remains in my girlogram. Though I have moved across the country since that time, Arlene has remained like a sister after all these years. Our bond was based on a spiritual and loving connection, which had nothing to do with our social status.

My friend Eileen has been an elegant teacher on how to bridge the disparity in social status between friends. When I met her, I was still a struggling actress, and she was already a successful businesswoman. She could buy anything New York had to offer. I was living like a starving student. Eileen never put me in uncomfortable situations. Though she owned many beautiful things, she never dragged me along on a shopping spree. She also didn't show off her purchases or brag about her lifestyle. She invited me to many wonderful events and graciously and quietly took care of any money that might be involved. She encouraged me throughout these financially difficult years and never failed to express her faith in my potential.

Both she and her husband, Ed, take so much pleasure in the success I have achieved. There was no difference in our relationship whether I was experiencing lean years or times of success. I have tried to learn from her example. Eileen taught me how to give to others without making them feel awkward or beholden. Perhaps Eileen's greatest gift, however, was when she invited me aboard her beautiful boat, *Eddie's Mink*. This introduced me to one of my great loves—boating. Now I get the chance to introduce other girlfriends to boating on my own boat, *Blonde Ambition*.

Eileen demonstrates that while friends of different social status have certain challenges, they also provide great opportunities to experience other ways of living. The familiarity that bonds Eileen and me is one of spirit, and this far outweighs the differences between us.

crossing cultural and racial boundaries

In addition to social status, culture and race are also part of the fabric of the new girls' network. I met Laurelle while waiting for a table at Paparazzi, my favorite restaurant in Washington. My friend Michael Palermo is the manager, and we often stand chatting at the front door. Laurelle was waiting with two male friends, and I overheard their beautiful accents. Laurelle is from Australia, and her two friends are from England. We started talking, and it was so much fun that we decided to get a table together. By the end of the evening, I was excited about the possibility of a new girlfriend. The next day, Laurelle invited me on a hike with a group of her friends. By the end of the day, I had met and enjoyed people from five

different countries, all of whom worked in the embassies in Washington.

i was backpacking through Australia and met a woman from England while traveling on a bus. We have maintained a long-distance friendship for fifteen years. My life is totally different from hers but we consider each other best friends.

My friendship with Laurelle grew strong and expanded to include her friend Mia, a beautiful New Zealander many years my junior. Mia worked as a nanny for one of the embassy employees. During the time I knew her, she went from being a nanny to running an entire office for an ambassador. My friendship with Mia introduced me to her embassy world and its fascinating Kiwi culture.

The fact that none of us had family in Washington drew us together. I enjoyed becoming involved with the embassies and learning more about the cultures of my friends. They loved having an American girlfriend. They joined me for Thanksgiving, Fourth of July, and all things American. I learned about "barbies" from the Aussies and curries from the Brits. There is a casual comfort in the Aussie culture, and it wasn't unusual for me to find one of them sleeping on my sofa after a social evening. I grew to enjoy their spontaneity and sense of fun. No matter how hard a day they had, their evenings would always be filled with humor and enjoyment. Even though they have returned to their home countries, they remain an integral part of my network of friends, and each has a special place on my personal girlogram.

Nearly two-thirds of the women surveyed for this book

reported having women friends outside their own culture. Responses were influenced by both age and race identification. Women who were younger and non-Caucasian were more likely to have female friends outside their own culture. In my experience as a therapist, I observe that, with young girls, success at developing cross-cultural friendships largely depends on the multicultural nature of their home and school environment. Girls who attend school where there are few children from other cultures often express lack of interest or more difficulty in this regard. The more exposure a person has to a variety of ethnic backgrounds, the more comfortable she is with the differences. Those fortunate enough to make this leap across cultural and racial boundaries are rewarded with a rich and varied friendship network.

my cousin married the most beautiful spirit of a woman who is so giving, honest, compassionate, and very wise. She is a calming force that emanates that feeling of "everything will be all right." Hwa Shin is from Korea, and gave up her way of life and family to join ours. She has such grace and wisdom to offer and is definitely an old soul. We formed an immediate bond and our relationship is proof that we are part of a universal womanhood no matter from what culture we originate.

My family moved to New Jersey when I began middle school, and I became the only Catholic, middle-class Italian girl in my school. My classmates were all extremely wealthy. Coming from New York, I went into culture shock. I was instantly relegated to

outcast status. Later, when I was in high school, my parents moved again, this time to Baltimore, Maryland. It was a blue-collar, multicultural area, and I was in heaven. Suddenly, I was no longer an outcast. I became a cheerleader, I dated boys, and no one laughed at my clothes. Even though there were few Italians, the students were so accustomed to the differences among their classmates that I was able to make friends.

Clearly, the more exposure we have to diverse cultures and races throughout our lives, the more likely we are to include a variety of women in our new girls' network. My best friends come from many different backgrounds, and each of us brings something special to the relationship. There is richness in our diversity. Because two-thirds of the women in our survey acknowledge having multicultural friendships, this richness is clearly enjoyed by women across America. By educating children to appreciate the beauty of diversity, we can help to lay the foundation for broadening the friendships in their lives.

Girlfriend therapy

1. Have you embraced diversity in your new girls' network?

2. Do you have any friends who lie outside your own social status?

3. Have you befriended a person of a lower social status?

4. Have you successfully held on to friendships after a major lifestyle change?

5. What can you do in the future to strengthen the new girls' network and reach out to women from different cultures and backgrounds?

the foundation
of friendship:
the early years

MOST WOMEN REPORT that by age six, they had both girlfriends and a "best" friend. These early years of friendship seem fairly straightforward, but as girls enter their preteen years, these important connections become far more complex. On a daily basis, I see the impact of puberty on friendships, since many of my clients are young girls. These girls sit in my office and pour out stories of rejection, jealousy, and victimization. Often they are too embarrassed to tell anyone else, especially their parents, who often remain ignorant of the social war zone through which their children must navigate on a daily basis.

During middle-school years, girls begin to separate into groups, forming their first social cliques. These exclusive groups

foster incredibly cruel behavior by ostracizing girls who don't "fit in." That is what happened to my client, Lily, when she was in sixth grade. Lily desperately wanted to belong to her school's "in group." Deciding to try the direct approach, she boldly walked up to the in group's table and set down her lunch tray. As she walked away to get some silverware, the girls at the table quietly picked up her tray and moved it to a vacant table. When Lily returned, she was devastated to find she had been relegated to the middle-school equivalent of Siberia. Despite this very public snub, she persisted in her attempts to befriend members of the clique. After a year of Lily following the girls around, sitting at the fringes of their lunch table, and joining every sport or club to which they belonged, eventually they began to accept her. Because Lily had strong emotional resilience and a high tolerance for rejection, she was able to endure the mistreatment long enough to achieve acceptance.

As adults, our ability to trust other women is highly influenced by the experiences of our formative years. Lily's prognosis is good. Because she had a strong relationship with her mother, she developed a strong sense of self that protected her when the girls excluded her. Lily was fortunate, because she did not believe there was something innately wrong with her. Without a deep maternal connection, many girls believe that there is something unlovable about them if they are rejected socially. They do not have the emotional resources to sustain them in adverse social situations. One survey respondent relayed a story that illustrates how a single comment by a peer can be life-altering (see page 115).

If we are not highly regarded in one area of our life, another area can expand to support emotional development. For instance, if children are emotionally neglected at home, their

when i was twelve or thirteen years old, in junior high school, my life was in turmoil. My folks were in the middle of a nasty divorce. My best friend and I were in the school bathroom and she made the comment that I was quite pretty, except for the fact that my nose was too big. That one comment from my friend absolutely crushed me and set me up for feeling a certain amount of insecurity that still exists today. Perhaps it was the timing of the comment. Today I still have the good friends that I had back in junior high school, we're close, and I'm careful to only make positive comments to them. My friend who made that comment has moved to a different state and we're no longer in touch. I guess the comments friends make to you are more powerful than family criticism. At least it was in my case, because it happened over forty years ago and I still remember it with a certain amount of pain.

friendships can give them a sense of belonging and self-worth. The point is we need someone to help us build our foundation of self-esteem. Girlfriends, as well as mothers, can provide this fundamental and necessary assistance. One woman we spoke to wrote about a personal success that wouldn't have happened without the support of her girlfriend: "When I was seventeen years old I joined Weight Watchers and lost sixty-eight pounds. My best friend at that time was real pretty and thin, but she stuck right by me, encouraging me, helping me watch what I ate and never ate things in front of me to tempt me. She was great. If not for her I don't think I would have done as well."

Girls who lack this foundation, however, often struggle with

lifelong issues of low self-esteem, depression, and anxiety. In my practice, I treat girls who have not received any sense of self-worth from either a parent or their peers. Their primary foundation of self-esteem was never laid. Therefore, they don't have the coping mechanisms to enable them to transcend the negative situations that plague them. They feign injuries so they will miss the Friday night dance. They stay home "sick," because they cannot face another day of rejection. These early negative experiences are internalized and can later manifest in problems such as alcoholism, drug abuse, or teenage suicide. In fact, many of my adult clients are still wrestling with the aftermath of these damaging early experiences. Often, these women had never verbalized their painful childhood memories. Although they had not made the connection between early traumas and current problems, their experiences were coloring the way they saw themselves.

How we process early traumas directly affects who we become and how we feel about other women. It took me twenty years to accept who I was and how I looked. I wasted a lot of time feeling bad about myself because a group of junior high school girls didn't like me. Another one of my clients confessed to hiding in the girls' bathroom rather than having lunch alone in the school cafeteria. She was well into her thirties before she could face walking into a restaurant and eating alone. "The memory of the social shame I felt, because I didn't have anyone to eat lunch with in eighth grade, took ages to fade away. It was years before I got to the point where I didn't feel that eating alone meant I was a social failure."

A mother or girlfriend can make the difference in how we view ourselves forever. One woman wrote us and said, "My mother always told me I was the best and most wonderful and beautiful,

which has caused me to grow up with the most confident and positive attitude of anyone I know."

Another woman had the exact opposite experience with her mother: "My relationship with female friends is open and honest—though I have only two. Hopefully, as I become more confident and able to deal with my childhood experiences, I will be able to nurture more female friendships. I believe the stronger the mother/daughter bond the more successful a person can be in relationships with other women. A negative relationship with one's mother can cause you to be on guard with other females, which is what happened to me."

These stories highlight the critical importance of our mothers and our girlfriends. It is they who are the cornerstone of our foundation, upon which a lifetime of friendship and trust in women is supported.

cracks in the foundation

Our research revealed that most women's earliest memory of betrayal by a girlfriend occurred between eleven and sixteen years of age. Even a girl with a fairly developed foundation of self-esteem will struggle when she is betrayed by a girl she thinks of as a friend. Unfortunately, acts of betrayal are prevalent in our early years. My theory is that as girls enter puberty and begin to compete for the attention of their male classmates, they shift from perceiving their girlfriends as playmates to considering them adversaries. What may have begun as absolute trust of other girls weakens into mistrust and confusion. With all the changes that assault young girls—physically, hormonally, and socially—their original foundation of self-esteem becomes paramount.

Katie and Sarah met over peanut butter and jelly sandwiches at their preschool lunch table and quickly became close friends. Wherever Sarah went, Katie was at her side. In kindergarten, Sarah seemed deeply attached to Katie. "You're my best friend," she would say, as she pulled Katie away from everyone else. As the years went by, the two friends shared play dates, swimming lessons, and ballet class. Katie seemed happily content to follow Sarah's lead, secure in having a best friend. All that changed in fifth grade, when Sarah suddenly dropped Katie in favor of a new best friend. Katie was devastated and completely bewildered by her abrupt loss. For the rest of their school career, Sarah never spoke to Katie again. This is the dark side of the adolescent experience of friendship. Betrayals can be heartbreakingly cruel and shape the way many women feel about themselves and other women for the rest of their lives.

my best friend of four years from high school decided one day to totally ignore me and ended our friendship without telling me why. We went to the same college and when I saw her there she still ignored me. That was the end; I never asked her why.

the mother's role

Many adult women remember the traumas associated with their early school experiences, but they assume there is little

they can do to protect their own daughters. "That's just the reality of life at that age," one mother explained defensively. But I contend that this is not true. Mothers can intervene at every stage by staying interested and involved with their daughters' lives. Mothers can be the safe haven where daughters express their daily challenges. In addition, it rests upon mothers to bolster a daughter's self-esteem, which will give young girls the tools to minimize their discomfort. In this way, mothers can help their daughters understand and maneuver the difficult adolescent social world.

Mothers also need to teach young girls how to treat one another in appropriate ways. They can teach young girls what is acceptable in terms of good manners and acts of kindness. Unfortunately, when girls reach twelve or thirteen years of age, many parents begin to pull back, bowing to the widespread belief that teenage girls must have privacy and independence. They are programmed to expect teenagers to feel alienated from their parents; they don't realize that at this sensitive age, young girls need their mothers more than ever.

Certainly, adolescents need to individuate from parents in order to become fully actualized adults. But they do not have to make this transition alone. They need guidance from adults as they continue to mature. Remember the "terrible twos"? That age was also about becoming more independent, but that did not mean the two-year-old didn't need her parents' constant, reassuring presence. Adolescents need a high level of parental involvement. Your daughter may overtly demand far more separation than she can actually handle. It is the mother's responsibility to monitor and direct her daughter's development. She needs to accept her role as an integral contributor to her daughter's emotional and social foundation.

My advice to mothers is this: if you want your daughter to learn how to be a good friend, it is important to model good friendships yourself. For example, telling your daughter she shouldn't be mean to another girl won't have much impact if she hears you laughing at your neighbor's hairstyle or sees you snub someone at your community picnic. Always remember, even if she seems to be engrossed in that teen magazine or video game, your daughter is watching what you do and listening to what you say. Do you model patience, tolerance, and acceptance, even to that tiresome woman at church? Do you go out of your way to befriend new neighbors, even though they are from a different ethnic background? You need to make a special effort not only to handle your own friendships appropriately, but also to make sure your daughter sees you doing it.

respect your daughter's privacy

Although it may be tempting to peek into your daughter's private diary or scan her latest computer log, your curiosity may be satisfied at a terrible price. Open communication is built on trust, and if your daughter doesn't think she can trust you to respect her boundaries, she is not going to confide in you about her problems. The best way to hear about what is bothering her is to take the time to build a trusting, intimate relationship. So how do you do that? If you are always running off to tennis lessons, or spending hours every day buried in work you brought home from the office, you cannot expect to develop open lines of communication with your daughter.

Communicating effectively takes time and effort, and a willingness to set up situations that encourage sharing. For example, spend some time with your daughter at lunch or by the pool. Take a shopping trip together and stop for tea at a special place. Then, once you've set up the environment, listen carefully to what she is saying. Many parents find that car trips make an ideal place to have heart-to-heart conversations in a non-threatening environment without distractions. "My daughter rides in the back seat," one mother commented, "and that's when the really heartfelt confessions pop out. It seems to have something to do with not sitting face-to-face that makes her feel more comfortable."

opening the door to communication

1. Choose your moment carefully. Don't ask, "What's wrong with you?" while you are racing to make dinner.
2. Honor your child's right to privacy and respect.
3. Don't have all the answers—listen.
4. Don't ask her open-ended questions. Instead of asking "How are you?" inquire specifically about the day.
5. Create fun time to share experiences or to just hang out and spend time together.
6. Keep a sense of humor; you'll need it with a teenager!

From my experience counseling teenagers, I have found that developing a serene style of listening encourages young people to open up. Listening means listening *carefully* to whatever she says, then planning a gentle response, and withholding judgment.

Try not to respond too quickly. The biggest mistake we make is that we try to fix our children's problem immediately. We jump right in with a solution. After all, we're the grownups; we know it all! Of course, the truth is we do not. It's important to remember that you don't necessarily know more about your daughter's problems than she does. You have had more life experiences, but not as an adolescent in the twenty-first century. When you listen to girls this age, think of yourself as a student, for their world is vastly different from your own.

Your goal should be to identify with your daughter, not to overwhelm her. Avoid suggesting in any way that your daughter's problems are not important, for as trivial as they may seem to you, they are extremely important to her. To brush aside a confidence with, "You're making a mountain out of a molehill. Who cares if you eat by yourself?" would completely compromise her faith in you. As you listen, remember that being physical also can be helpful. If it feels natural and comfortable, offering a simple hug can help to dissolve the barriers. Try, at least, to connect with a gentle touch that says, "I'm listening, and I care."

It is also important not to ignore or accept depressed or negative behavior in your children. Such actions are a cry for help and are therefore too important to let go unchallenged. While adolescence is a time of strong and fluctuating emotions, seriously negative moods are not a normal rite of passage. Many girls who suffer torment at school will appear to be quite depressed, but others will put on quite an act ("I don't care!"). Be alert to subtle changes in your child, such as different eating habits, dramatic changes in the people she befriends, lower grades, or secretive behavior. Whatever the manifestation, it is important to recognize the troubled young hearts beneath

these protective shields. Communication is the key, and listening is the means.

warning signs

if your daughter exhibits these signs, pay attention and investigate the cause. Seek professional help if necessary. Don't wait.

1. Comments like, "I don't care if I live or die" cannot be taken lightly. Find out if she has any sort of destructive plan in mind. Take it seriously.
2. You (or a teacher/administrator) observe a change in your daughter's behavior at school, a drop in grades, different friends.
3. She disobeys her curfew and/or comes home intoxicated or drugged.
4. She sleeps during the day and refuses to go to school.
5. Your daughter is avoiding food, or binging and purging, and you suspect an eating disorder. If you think it is happening, it probably is, so get professional help. Start with a referral from a friend, ask your doctor, or look in the Yellow Pages for a licensed professional.

share your own stories

When girls of this age look sad or detached, you cannot simply ask, "What's wrong?" and expect an answer. You need to engage them.

It's helpful for girls to hear that their mothers, aunts, grandmothers, and other older women all had problems when growing up, too. To build empathy with your daughter, share your own first experiences of challenges such as jealousy and betrayal.

My young clients love hearing that "someone like me" was a social outcast in adolescence. They see me as a successful professional with lots of great friends, and they love hearing the story about the time I threw a Halloween party and no one came. Hearing these stories gives them hope for themselves, and of course that is just what they need.

For example, a year ago I visited my girlfriend Nancy and her young daughter, Ginny. As we chatted, I noticed that her daughter was clearly depressed. However, she would not respond to her mother's direct questions about her feelings. Later, I proposed we have a hair-styling session. As I combed and curled Ginny's hair, I told stories about when I was eleven, and how the other girls made fun of my curly hair, because straight hair was "in." At first, Ginny merely listened as I went on and on, talking about how I was one of the "weird" kids who were always left out.

"That's just like me!" Ginny suddenly blurted out. Sad, painful stories about her life at school began to pour out, details her mother had never heard. Her mother was shocked, but it opened the door to a whole new level of communication and problem solving between them. My method was successful in helping Ginny open up, because in these situations, direct questioning almost never works. If a girl does not fit in or have a best friend, she sometimes believes there must be something wrong with her. Many young girls find rejection deeply humiliating, and they aren't willing to risk compounding their plight by sharing their hurtful experiences. To get Ginny to open up, I needed to

establish a bond of trust by demonstrating that I could empathize with her. I had to reveal myself to her. I had to confide some personal secrets. It works almost every time. Rare is the child who is willing to bare her soul first. However, in a conversation where you start the ball rolling, you may be surprised at what you discover.

if your daughter is being excluded

Once you have taken the time and set the stage for good communication with your daughter, you may be stunned at what you uncover. You may have assumed your daughter was doing just fine at school, only to discover she is being excluded by other girls. If this is the case, take action right away. If you suspect your child is having a problem making friends, the first thing you should do is honestly examine yourself. If you experienced cruelty from girls during your adolescence, there is a possibility that you are projecting your own pain and disillusionment onto your daughter. Maybe your child only has one or two friends, but she is completely happy with that. If there is a clique that is excluding her or others, she may not be interested in being friends with those girls.

Middle-school cliques are inevitable. Every school in every town has the football player groupies, the cheerleaders, the brainiacs, the computer nerds, the science geeks, and so on. Each group forms an exclusive subset within the school hierarchy. What is important is how you daughter reacts to them. If you discover that your daughter is upset about being excluded by other girls, talk to her about possible reasons why. Girls of this age will often pick on any child who does not conform.

If she seems embarrassed because of crooked teeth, a speech impediment, or the lack of the latest clothing styles, is there any way you can help her to attain the vision of what she would like to be? Individuality is a wonderful trait, but for girls this age, fitting in with their peers is of developmental importance. You can work on bolstering her independence and sense of adventure later.

i met my best friend Tanya when we were twelve years old, and I moved in next door. I was the lonely awkward new kid, and she had lots of friends. The only thing that stopped me from killing myself over the horrible treatment I had at school was Tanya's friendship. We've been best friends ever since—for the past thirty-eight years.

A neighbor of mine, Paige, was an intelligent, inquisitive child with bright red curls and a serious weight problem. As early as first or second grade, Paige was unhappy about her excess weight and became depressed and sullen. By the fifth grade, she was ignored by everyone in the class. It was difficult to tell which of her friendship problems were caused by her weight, and which were caused by her negativity. When her mother realized how much her daughter's weight problem was affecting her life, the two worked together on a healthy eating program. Her mother replaced criticism with guidance and encouragement. A highly motivated child, Paige was spectacularly successful, and by the time she entered high school, she had shed fifty pounds. Encouraged by her parents, she took up soccer and tennis. Her success was reflected in a dramatic improvement in her mood

and emotions. As Paige became more active, she began to establish several good friendships at school and was no longer depressed.

Discovering your daughter's special talents and encouraging her to develop an interest in outside activities is helpful, but be careful not to project your own interests onto your daughter. If you love horses, you will be wasting your time trying to turn your daughter into a Grand Prix jumper if her passion is tennis or music. If she is an avid reader, help her start a Mother/Daughter book club. If she loves to dance, encourage her to enroll in classes. If she is doing something she loves, your daughter will naturally feel more confident, and she will have something in common with other girls doing the same activity. Her sense of self-esteem will be enhanced, which will help her in all her social situations.

Working on your daughter's strengths and weaknesses is only part of the plan. It is also important to give girls the tools to defuse hurtful situations. One of my young clients told me a story of how she handled a painful childhood incident. A friend came up to her at school and said, "Jackie and Stephanie said they don't like you!" My client responded, "Well, that's too bad, because I like everybody." That's the attitude you want to foster, and it reflects the depth of one's feeling of self-worth.

You can also work with the school by offering suggestions on how the administration can anticipate hurtful situations before they arise. At one small high school in Alexandria, Virginia, the principal set a new rule on the first day of school: for the first month, everyone was given an assigned seat at lunch, intentionally breaking up groups of girls, thus providing the opportunity for students to meet others with whom they normally wouldn't associate.

Of course, some girls' problems are deeper than not having the right hairstyle or lacking interests. Some girls have personality disorders or have not yet developed the appropriate social skills they need to make friends. It is a big mistake to assume that a child who does not know how to make friends will somehow learn how to as she gets older. More than likely, a child who lacks social skills in first grade will only develop more serious problems as she gets older, as experiences of rejection from her peers accumulate. Most of these developmental problems can be addressed by an astute, involved parent. If the child does not respond, it is imperative to get these children professional help as early as possible, so they can learn appropriate social skills before too much damage is done.

if your daughter is excluding others

All too often, parents of girls who belong to cliques that actively exclude other girls are the last to realize the problem. "I got a call from the school the other day," one mother exclaimed. "They said my daughter was the leader of a clique. Imagine that!" Her attitude and irritated shrug showed that not only was she unaware her daughter was excluding others, but she did not really care. Her attitude was, "Big deal! Isn't that what middle school is all about?" She may also have secretly been proud that her daughter ran with the in crowd. Such behavior may be widespread, but that doesn't necessarily mean that it is desirable or even acceptable. Allowing girls to get away with mean, spiteful behavior in formative years fosters character traits that will become increasingly problematic in later years.

If you discover that your daughter is excluding others, the first person you should look at is yourself. Is your daughter learning this behavior from you? Do you leave others out or act in inappropriate or hurtful ways? Did she learn from you that it is acceptable to be rude or cruel to others? The realization that "I am turning into my mother!" is a sobering thought if you look at yourself honestly in the mirror and see that your daughter is patterning herself after you.

When a girl is excluding others and behaving in mean, hurtful ways, we need to intervene. That intervention can begin with neighbors, parents, teachers, or school administrators, but it needs to begin right away. Our news lately has been all too full of violent acts triggered by bullying or excluding behavior. We need to talk to our children, both individually and in groups. Getting girls to discuss their experiences and educating them about the true nature of what is going on is incredibly effective. I am often amazed at how much better these girls do once they understand what the ramifications are when girls reject other girls.

You need to act immediately to let your daughter know that deliberately hurting others is unacceptable. You should make it clear to your daughter that you will not tolerate meanness. Do not hesitate to use consequences every time you notice your daughter harshly criticizing someone else. Be sure you tell your daughter, "You don't treat anybody like that." And work hard to model kindness in all that *you* do.

It is tempting to be negative toward girls who are excluding others; how could they be so mean? We need to remember that when girls exclude other girls, they are acting out their own pain. This is exemplified by Paula, who moved to a new school in the sixth grade. "In my other school," Paula told her new classmates,

"everybody said I was mean." She wore this designation almost as a badge of honor. Hypercritical of even her closest new friends, Paula set the groundwork for the inevitable backlash her actions created. What her new classmates had no idea of, however, was that Paula's father had just abandoned the family, and her parents were in the process of divorce. As they licked their wounds caused by Paula's verbal assaults, her classmates failed to see the frightened little girl filled with loneliness and feelings of rejection. Paula's coping mechanism was to take the offensive by criticizing her friends and classmates, turning them against her before they had a chance to reject her.

The girl who is excluding needs as much kindness as do the girls who are excluded. She needs clear boundaries, because she may be too young to understand that boundaries of acceptable behavior exist. Far too often, parents fail to perceive how their daughters are relating to their peers. Don't wait for that call from the school principal. Mothers need to be on the lookout for situations where harm can be inflicted. For example, if a daughter is having a party, a wise mother will look over the invitation list to see if someone is being excluded unfairly. If so, this is a good opportunity to point out the pain caused by her actions. The mother should tell her daughter to put herself in that situation and ask how she would feel if *she* were excluded from a big party in the neighborhood.

Sometimes, that is all it takes. If your daughter digs in her heels and says, "I wouldn't care if she didn't invite me, she's a creep," you have to be prepared to take action. If pointing out the ramifications of hurtful behavior is ignored, you may need to enforce consequences. If a mother finds a situation where her daughter is creating a mean or harmful social environment by excluding someone, the response should be simple: don't let her

have the party. This naturally takes all the enormous strength of a mother's resolve, for the ensuing battle will not be pleasant. Remember, the rewards for your efforts in the early years of character development will pay dividends far into the future.

We are trying to create a better world. One way to do this is to raise children who are kinder to each other. No matter what side of the equation your daughter is on, whether she is excluding others or being excluded herself, she needs your guidance. By acknowledging the critical importance of these years, we can change the lives of so many young women. Keep things in perspective: Your daughter doesn't have to be the most popular girl in the class to survive. Even a single best friend can make the difference between adolescent angst and happiness.

Girlfriend therapy

1. Analyze the friendships you remember from your child-hood. Were they generally positive or negative? What can you do to resolve any issues that may linger from these early friendships?

2. What kinds of friendships are you modeling for your young daughter?

3. Youth often look outside their homes for role models. What types of friendships are you modeling for your young sister, neighbor, or friend?

4. Are you listening to your daughter and sharing stories about your early experiences with friendship?

5. Are you communicating often with your daughter about friendship?

6. Are you encouraging your daughter to be inclusive and become friends with a variety of individuals?

7. Do you consider yourself to be the best friend of your grown daughter? What might be the negative side of such a relationship? What does your daughter think about this relationship?

best friends 8

O EVALUATE THE type of friend you are, you must first define what a girlfriend means to you. Your picture of friendship is influenced by many things. The story of your childhood, early girlfriends, and the model of your mother and her approach to friendship all laid the groundwork for what you believe today. There is also the concept of "best friends." It seems that this practice of choosing one girl to be a better friend than another dates back to grade school. At that time in our lives, choosing one friendship and placing it above the others seems to have made us feel safe.

I now believe that all of my girlfriends should be my best friends. Why would I want a friendship that isn't great? When you look at your girlogram, you might want to think about the

women that you consider your best friends. Eventually, they will create the core friendship circle upon which you will build the family of your friends.

what is a best friend?

The majority of the women we surveyed said they have a best friend. By calling it "best" are women saying these friendships are better than others, or simply different? Whatever the underlying reason, "best friend" appears to be a concept that starts young in life and continues on in later years. In 1987, Carol Becker published a study in the *Journal of Phenomenological Psychology* that examined the foundation of the best friend phenomenon. She found that a loving relationship and a shared world were critical to women. Caring, trust, commitment, freedom, respect, and equality were also highly rated. What they valued within these best friendships was being able to engage in their own pursuits, while sharing their friend's experiences.

As I interviewed women for this book, many mentioned the "safety" and "comfort" of having a best friend. They described feeling "most understood" and "most relaxed" with their best friends. Over and over I heard, "I can tell her anything." Not all best friends even live close to each other. Some women described seeing their friend only a few times a year, but said they still considered themselves "best friends." Women described "ease of conversation" with best friends. "We can pick up right where we left off." No matter how much time passes, "It feels like we were together just yesterday."

the time in my life that I enjoyed the most was the ten years I spent living next door to my best friend. We shared everything. I even knew when her husband was going to "get" sex before he did. We shared yard work, gardening, car washes, lots of laughter, and lots of tears. Even though we are no longer neighbors and we've grown apart, those were probably the best years of my life. I was never alone.

Best friends are the ones who save you when you need help the most. One woman wrote:

> After my divorce, I rebounded to another man and moved to a small town. The new relationship only lasted two months and I found myself lost in a strange town with no friends, no job, no financial resources (due to bankruptcy), and nowhere to live, with a ten-year-old daughter, a sick dog, a broken-down car, and three cats. My best friend took me under her wing, fed us, helped us find a place to live, and provided lots of emotional support during the worst crisis of my life. She understood and gave me a safe place to turn for the first time in my life. I thank God that she took me under her wing when she did. I will forever love her as a friend, a mother substitute, and a guardian angel.

For many women, the appeal of having a best friend is *being* somebody's best friend. It is comforting and reassuring to be thought of as a best friend. It implies that we are deeply connected to someone, depended upon, and thought about. It says we matter to someone.

But not all women have best friends, and some women in our survey reported they didn't have any good friends at all. I have had many clients who felt alone and separated from other women. Even women who had initially said they did not want girl friends eventually admitted they did not know how to make a friend. When they finally were able to connect with someone, they came to treasure that friendship, viewing it as an important part of their lives.

Sometimes women need to make a conscious decision not to be involved with certain people. One of my clients lived in the Cayman Islands for a number of years and decided that the women who lived around her would be a bad influence if she befriended them. She described them as hardened women who gossiped endlessly about each other. She later moved to Florida and met a new set of softer women with whom she could be more relaxed and open. She said she instinctively knew these women would be a good influence in her life, and that they would value the friendship she offered. She described her island period as one of the loneliest in her life, and she feels blessed in her current situation.

mothers and friendship

Mothers have a direct impact on how we think about our best friends. Although most of us do not want our mothers to be our best friends, they do influence us in many deep and abiding ways. Mothers are our first female relationship. The level of trust and the safety we experience with our mothers can forever influence our views of other women. If your mother didn't trust other women and embrace best friends, there is a high probability that you will not

be comfortable with the idea of best friends either. On the other hand, if your mother had a close circle of best friends, it will be easier for you to welcome girlfriend opportunities and expect them to be a fulfilling part of your life.

the "business" of running a home

my mother never really fell in love with her children the way most women do. She didn't have many close friends and openly trusted very few people. Though she was wise and strong, my mother was somewhat cold and isolated, even with her own children. In her later years, watching me care for my little ones, she often said she regretted running her home "like a business." I didn't know any better, she used to say. "I thought it was about work, cleaning, laundry, and schedules. I can't do anything about it now, but I wish I had done it differently."

You can imagine that with her home as her "business," my mother had very little time for friends. In fact in all my years at home, I never once remember my parents hosting a party, inviting friends to dinner, or going out with other couples. My mother had a few women she called "best friends," but on reflection, these relationships were mostly carried out at church and quite superficially within the neighborhood. If these friends did arrange a lunch or an event together, Mom would make certain to drive on her own so that she wouldn't be tied to their schedules. "Honey," she used to say to me when I questioned why she didn't spend more time with other women, "you know me . . . I just like to be independent. I don't need people like others do. I am never bored by myself, and I love to do my own thing,"

I can unequivocally say that I was raised by a mother who "did her own thing!" And that upbringing has played itself out hundreds of times in all my relationships, especially with girlfriends.

Though I've always viewed myself as independent, I'm extremely sensitive, and was never happy on my own as my mother claimed to be. My mother's "business" didn't allow for real connection with her children, and she didn't model friendship in a way that I ever understood. So while I needed friends, I didn't really have the skills to build solid friendships. I constantly had people around me, but I rarely trusted them, and never connected enough to really stay in contact or carry on a friendship for more than a few years.

A vast majority of the women we surveyed said that their mother did have close, highly valued female friends, and about 60 percent felt that their mother was important as their role model. Fifty-seven percent rated their present relationship with their mother as "good" or "very good," and most women reported currently having contact with their mother at least once a week.

Many mothers tell me that their daughter is their "best friend," and that they "share everything with her." This always makes me uncomfortable. My observation is that whereas mothers enjoy a best friend relationship with their daughters, most daughters do not want their mothers as their best friends. Once children are verbal and independent, they prefer their peers as best friends. A mother who can let go of the best friend role as her child develops allows that child to begin her own "new girls' network."

Once I was a guest on CNN in a segment about mothers and daughters. The interviewer asked me what I thought about moms and daughters being best friends. I said that I believed it was not an appropriate relationship. Mother/daughter relationships are inherently different because best friends share the most intimate parts of their lives with each other. Daughters, especially young daughters, should not be privy to this type of intimacy.

The interview continued, and, then to my surprise, the CNN anchor introduced several extremely prominent women who were hooked up via satellite with their daughters. These women enthusiastically talked about their daughters and the "best friend" relationship they shared with them. Before I could even respond, the interviewer turned her attention on the daughters. Interestingly, none of the daughters expressed wanting her mother as her best friend. A revealing discussion ensued, and the daughters made it clear that they did not want that kind of intimacy with their mothers.

One of a child's developmental tasks is separating from his or her parents. Forming friendships within a peer group can help a child accomplish this. Before puberty, daughters naturally consider their mothers to be their best friends. It's important, however, that the mothers refrain from sharing information that is inappropriate. As children become teenagers and struggle to become independent, they never want their mothers as best friends. Even as young adults, most women are not comfortable knowing intimate details about their mothers. Very often it is the mother who needs or insists upon this closeness. I believe that we should respect the generational differences between us. We can have a lot of best friends, but only one mother, and most of us need her to remain exactly that.

the beauty of best friends

The feeling of being known provides great comfort to most of us. And it can be the smallest thing that brings us joy and binds us together. Many respondents to our survey told beautiful stories about their best friends. I am inspired and moved by the depth and appreciation these women have achieved within their relationships, and I find myself reflecting on brilliant moments of friendship in my own life. I remember those times when a best friend lent me money, listened to me struggle with a problem in the middle of the night, or encouraged me to become the person I wanted to be. They mothered me, assisted me, and most of all taught me what it was like to have a real friend.

i was pregnant with my first son and having some problems in my marriage and scared to death. My girlfriend took me under her wing, helped me work through my marriage problems, gave me all her baby clothes, and hand-knitted a baby blanket. We were shopping one day, and I spotted a hand-carved cradle that I wanted very badly, but couldn't afford it. After I went home, she came over the next day with the cradle. I have kept the cradle all these years, after using it for my second son. It has also been used by two nephews and one niece.

For some women, these magical experiences of friendship are elusive. But you must not give up. While it is important to

examine what you may be doing to derail this type of friendship, it is equally important to believe that you are innately lovable. You must be open to people you meet and willing to move carefully along the road of friendship to develop best friends. Nurturing and believing in a new, well-chosen friendship will help you develop the kind of bond many women enjoy.

my best friend is deaf. She went deaf gradually and didn't know it was happening. I finally told her she needed to do something about it. She needed to have someone call for her daily job assignments—she installed telephone cable for businesses. She had to have her hearing tested in order to qualify for a TDD (telephone device for the deaf). I went with her to the doctor, and when we left she was angry with me. A few weeks later she got her TDD and called me. She said I had given her her life back. She was independent again. She could call for pizza or make doctor appointments. I felt great!

A true friend may be as close as your next-door neighbor or the woman who serves you breakfast at your local restaurant. A friend of chance or convenience may become a long-term, well-chosen friend. Allowing clarity and an open heart to lead you instead of a critical mind can bring you to the best friends of your life. We can find the family we desire in the hearts of our female friends. We can determine what we desire in a friendship and what we are willing to give as a friend. An open heart and a giving spirit is the starting point for a healthy, positive, life-enhancing relationship.

\mathcal{G}irlfriend therapy

\mathcal{T}ake this **girlfriend quiz** to get an idea of who you are as a best friend. Answer each question with a yes or no.

1. Are you reliable in your friendships?

2. Do you truly want the best for your friends?

3. Do you create and promote harmony in the lives of others?

4. Do you listen?

5. Do you keep your promises?

6. Are you willing to reach out when there is a need?

7. Are you always respectful of your friends?

8. Can you be trusted?

9. Can you keep a secret?

10. Would you always try to protect your friend?

Now give yourself one point for each yes that you answered. If you scored less than eight, you have work to do. Consider which questions you answered with a no. Determine to change so that you can become a better friend.

Always remember the saying, "The best way to 'have' a good friend is to 'be' a good friend."

taboo
topics

ERTAIN SUBJECTS MAY make us feel embarrassed, angry, or alienated, and I refer to these as taboo topics. These are the areas that are often difficult to discuss even with close friends. But the benefits of sharing these intimate details of our lives with the right person are immeasurable.

Recently, a client told me of a life-changing conversation she had with her sister while sitting on the beach one afternoon. My client's marriage was fairly happy, but there was little intimacy. "So, how many times a week do you guys have sex?" she asked, trying to downplay a subject that had caused her so much sadness and pain over the years. Her sister turned to her with an astonished look on her face as said "Are you crazy? How many times a week? You mean, how many times a month!"

This one exchange helped my client see her own situation in an entirely new light. She was astounded at how much better she felt, after simply sharing what had become a shameful secret. To learn that her situation was not as unusual as she had thought gave her the courage to move forward and talk more openly about it with her spouse. By being willing to broach a taboo topic, this woman changed her life in a positive way.

According to our survey, my client's experience is not out of the ordinary. A substantial number of women surveyed reported that they didn't talk to their girlfriends about sex. We found it was the one taboo topic among women. As a therapist, I believe it is a topic that needs to be talked about with trusted friends, because there is so much misunderstanding about this important aspect of our lives.

Our society is preoccupied with sex. Sex sells everything from cars to shampoo. You can watch it on daytime, prime time, and late night television. We see it in the movies, read about it in magazines, and can easily find it within a few keystrokes on the computer. We are literally bombarded by sex.

Despite all the hype and exposure, however, many couples are missing the deep connection that sex can bring to a relationship. This connection is vital, and when absent, it often leaves partners feeling inadequate and lonely. These feelings are compounded by a reluctance to discuss this intimate subject. For a variety of reasons, sex remains a topic that otherwise savvy women find uncomfortable to discuss, even with their girlfriends.

If we do talk openly to a trusted friend, we usually discover that our secrets are not really as dark and unusual as we thought. I have told many clients that while most people today are constantly talking about sex, few people are actually having a lot of it, and fewer still are doing it well. Women that share this type of

intimacy say they feel closer to each other. One woman we spoke to shared with us this type of female openness:

> **my girlfriend and** I tell each other everything. There is no topic that goes undiscussed. We even talk about the size of our boyfriend's dicks and the way they make love. It feels good to let someone know the details of what goes on in your life. A lot of the time we end up laughing at ourselves but just talking about that intimately brings us closer together as friends. I know now I could tell her anything and she wouldn't freak out.

I found out after a decade of friendship that one of my closest friends had never experienced orgasm. She felt completely frustrated and depressed about it. When she finally mentioned her problem to me, it was a huge relief for her. She said she felt better after sharing it with someone, and I was able to tell her that she was by no means alone.

Her situation is hardly unique. I have counseled dozens of women over forty who have never had an orgasm. Many of these women feel like a failure. Yet, if they had talked to their girlfriends they would have realized their situation was commonplace.

Women who do report talking about sex say they tend to talk to men. Unfortunately, this is usually not helpful, because men generally have a completely different view of the subject. Honest communication between girlfriends could provide valuable information about women to women.

It comes as no surprise to me that women do not talk freely about intimacy. Being raised as an Italian Catholic, I was not encouraged to be open and honest in this area. In my training as

a therapist, this eventually became a problem. As I sat in my first human sexuality class, it suddenly dawned on me that I would actually have to discuss sex with clients. I was terrified! But as the months passed, and I worked face to face with patients, my fear and uneasiness with this subject faded. My clients clearly needed a place to unburden themselves, and often my office was it. I watched truth and openness lead to transformation, and I was grateful to provide an environment where this was possible, without risk.

Over the years, I have heard incredibly intimate details of my clients' sex lives. I have seen their courage in facing these very personal issues. I am continually awed by my clients' openness, and I am grateful that caring and listening can be so healing.

bisexuality and homosexuality

Discussing the subjects of bisexuality and homosexuality can cause even more discomfort for many people. No matter how far we have come, in our culture, being heterosexual is far easier than being anything else. We may speak about tolerance, but ask anyone who is different, and they will tell you another story. Initially, we had difficulty getting women to agree to participate in our girlfriend survey. Many misinterpreted it as being about "lesbians," though we presented it as research on "women's friendships." Eventually, we had to rephrase the interviewer's introduction to clarify that this book was about all types of woman's friendships, and that it was not a book about homosexuals. We also received several letters from women who were against "this type of research." One actually accused us of being "against family values," and others were clearly just unnerved at looking at this part of their lives.

Most of us feel safer when we are similar to those around us. As a therapist, I observe how many of the secrets people reveal are alike, yet each individual's life experience is remarkably unique. In therapy, we work toward accepting whatever we are, as long as it does not injure another person.

> **my dearest, closest,** oldest friend is a lesbian. I have never had any type of relationship with her other than friendship. Our parents were friends and we grew up together. When we were teenagers I helped her with relationships with females and she helped me with relationships with males. In other words, we always felt we were partners in crime. I would cover for her and her for me. I had strict parents and would stay at her house a lot. She would help me see my boyfriends, would go along with me, and many a time would get in trouble with her parents because we left the house. But she would always do it again. I am forty-two years old and still she is the best friend I ever had. I have always trusted her (and only her) completely. I love her with all my heart and always will. We are still very close, and I am also close to her female lover of about twenty-six years. I am also still close to her family. Even though I don't see her real often, I know with absolute certainty that she is there for me if I need her. When my husband and I have problems, that's the first place I go.

It's impossible to know how many women secretly wish to have sexual intimacy with a friend, or those who have had such an experience but do not admit it. I have had a number of

female clients admit, after many therapy sessions, that they had been attracted to another woman. Often this admission comes out very slowly during our work, with the client watching intently for my reaction. I tell them that they are not "weird" or "bad" for having these feelings and inform them that many women feel the same way. Then, they usually relax and begin to explore these feelings more freely, finding comfort in the knowledge that they are not alone. When you listen to people's secrets and dreams, they often involve bisexual elements.

I had a client tell me in tears that she dreamt about romantically kissing her girlfriend. This client lived a totally heterosexual lifestyle. She was completely relieved when I suggested that perhaps the dream represented nothing more than deep feelings of affection for her girlfriend. But what if this client actually was bisexual? She acted as though she would kill herself, if this were true. Many people are afraid that there is an underlying bisexual aspect of their nature.

My personal view is that bisexuality is far more prevalent than is reported. We certainly know that the number of gay women in our country is vastly underreported. I have had many clients who have lived a gay lifestyle for years, and yet no one in their work circle is aware of their lifestyle. When I asked these women why they keep their sexuality a secret, they report experiencing a high level of homophobic behavior in the workplace. The idea of being alienated from those in their office was so distressing that they preferred to pretend to be something they were not. If my clients were comfortable with their lesbianism, however, they tended to have a well established network of friends who were either lesbian themselves or comfortable with that quality in their friends.

If our girlfriend relationships can provide us with the acceptance to be our true selves, much healing can occur. Unfortunately, many women are extremely uncomfortable with the idea that one of their close friends is a lesbian. They sometimes react as if their lesbian friend might take advantage of them and force their lifestyle upon them. Our sexuality is deeply seated at the core of our being, and it is impossible for anyone to "convert" another person to a sexual lifestyle that is contrary to her nature. The truth is most people merely want to be accepted for who they are.

When I was in college, I worked as a cabana girl at Mount Airy Lodge in the Pocono Mountains. I worked closely with a group of girls who were the lifeguards and restaurant staff at the hotel. Living conditions were quite intimate and very basic. Several of us bonded in a very special way and still remain great friends thirty years later. Our first five-year reunion was held at a restaurant in Los Angeles. I was the last to arrive, and when I did I found myself in a group of ten women.

As the evening progressed, they all started giggling that I was "the only one." I had no idea what they meant. One finally explained that they were all gay. My first reaction was surprise that I had not realized something so important about my dear friends. It also was the first time that I had become aware that any women I knew were gay. I had had several male gay friends, and I was quite comfortable with those relationships. However, somehow the fact that these were gay women unsettled me. I have to admit that as I let this information further sink in, I became aware that I was upset and hurt. I felt that I had been left out, excluded from the truth about the group. I had always thought I was not pretty enough as a child for my father, so I thought perhaps I wasn't attractive enough for them. Of course, it had nothing to do with

my looks. They respected the fact that I am straight and knew I would be uncomfortable with any sexual advance on their part.

With whom we choose to become sexually intimate is a private and sacred choice. My lesbian friends were still exactly the same people that I had loved and befriended five years before. The difference in our sexuality did not stand in the way of their loving me. As I assimilated this new knowledge about them, I chose to love them in return. They were, after all, my girlfriends.

Since our reunion, my friendship with this group of women has grown even stronger. I thank these brave women for teaching me that a kind heart and good intentions are the only essential qualities inherent in true friendships. Their sexuality and their willingness to discuss it have enabled me to listen more comfortably to the intimate details of my clients' and girlfriends' lives. It has allowed me to stay more open to all facets of my own nature. My hope is that this book may encourage women to open themselves to the diversity of the world and to broaden their circle of girlfriends to include women who may lie outside their comfort zone.

There are two levels of acceptance that come to bear in forming close friendships: acceptance of others, and even more important, acceptance of ourselves. Being comfortable with ourselves is essential for a healthy life. The more we deny, suppress, or judge our inner feelings, the more depression and anxiety we are likely to experience. If we accept ourselves for who we are, negative emotions decline. Optimism will grow as we begin to feel more in sync with our essential nature. We will thereby bring to the table of friendship a healthier, more accepting self. And we will be a more valuable friend to others.

I say all of this with due respect to those readers who hold religious or philosophical beliefs that make them uncomfortable with this topic. Regardless of one's fundamental religious or cultural edicts, certain people will struggle with their sexual orientation and subsequent guilt. Part of my job as a psychotherapist is to help my clients to process and eliminate shame and sexual self-loathing. This invariably leads to a greater feeling of self-worth, which in turn favorably affects all the friendship relationships in which they participate.

One of my clients grew up in a small town in the Midwest. During junior high school, a rumor started that she was a lesbian. The rumor was not true, but it circulated throughout the school and eventually throughout the small town. No matter how hard she tried, the shadow of this rumor influenced her entire life. Boys couldn't ask her out without fear of ridicule from their peers, and girls were afraid they would be mislabeled if they befriended her. High school became a terribly painful experience. Although she went away to college, she lived in fear that somehow this rumor would follow her. When I met her, she was in her thirties and still suffering from the aftermath of this rumor. She had begun to doubt herself and wondered if there was some valid reason that her classmates had labeled her in this way. Not only had this rumor affected her romantic relationships, it had also made her afraid of connecting with girlfriends.

Over time, we sorted out her sexuality and healed the wounds created long ago. The fact that she was, indeed, heterosexual, was only part of the story. If she had been gay, the way she was treated would have been equally deplorable. Defending her heterosexuality had for a time forced her to become homophobic herself. Once she became comfortable with herself, she was able to accept

differences in the sexuality of others. Though still tentative, she is now exploring the waters of friendship and slowly expanding her personal "new girls' network."

In our research, women reported little sexual activity with other women. A total of 6 percent said they have had a friendship become sexualized. About 5 percent said that they are currently having sex with another woman, while 1 percent identified themselves as having a lifelong female partner. Women also reported that their first sexual experience with a female occurred between the ages of eleven and fifteen. This fits with the theory of heightened sexual experimentation during puberty. It also reinforces the need for us to discuss sexuality with our daughters and young women in our care at an early age. I have heard many gay women describe their fear and isolation upon recognizing their homosexuality. They describe having absolutely no one with whom to share this information. Unable to accept the truth about their sexuality, some went on to marry and to create families that they ultimately felt compelled to leave. Others had secret lives and lived in constant fear of discovery. Until women feel they will not be ostracized by their friends by revealing their homosexuality, these situations will continue to exist.

gay male friends

A book on girlfriends would not be complete without honoring the vast number of women who enjoy a similar type of friendship with gay men. If I had constructed my girlogram thirty years ago, when I was a struggling actress in New York, it would have been filled with the names of gay men. I met my friend Russell in a restaurant in New York, where I was working as a waitress. I had

greatly exaggerated my restaurant experience and was saved by my new friend during my first night on the job. Russell told me to keep smiling, and he would cover for me in my station. In future weeks, he taught me the art of waitressing, bartending, and catering. He introduced me to many other fine gay men with whom I developed close friendships. I know I wouldn't have survived those early years in New York without these dear friends.

Russell and I went on to write a successful book together titled *Recipe for a Great Affair*. AIDS tragically claimed the lives of most of these men, but they remain in my heart with the same reverence as my best girlfriends. Many women that I interviewed told me of relationships with gay men that were the best friendships of their lives.

sexual assault

I work with many adolescents who think nothing of accepting rides with strangers, sleeping over at new acquaintances' apartments, and walking alone at night. Often, they have no idea that "date rape" is fairly common. Many say they talk to absolutely no one about this subject and therefore receive no information about protecting themselves. As young children, they were taught not to go with strangers, but as adolescents, they need to be taught how to enforce boundaries with friends and family. Nearly 40 percent of our surveyed women reported being sexually assaulted by a man, and 7 percent were victimized by another woman. Thirty percent of these incidents happened to women before the age of twenty-one.

We need to talk to each other and especially with our daughters, students, and friends about the prevalence of sexual assault.

No matter how far we think we have come, there is much further to go. Education begins with communication, which can help us protect ourselves, as well as the ones we love. Sharing our concerns, our problems, and our solutions can help us all reduce our risk and exposure to assault. Following is the story of a young woman struggling in the aftermath of childhood assault, compounded by anxiety about her homosexuality. It illustrates the value of honesty, communication, and acceptance, as well as the need of parents to stay connected to their children.

jennifer's story

When Jennifer and her father first arrived in my office, her father made it clear that his daughter was a problem, and that he was hiring me to fix her. He informed me that the house-keeper would drop her off for our appointments, and my fee would be mailed each month. With this, he excused himself and left. My initial session with Jennifer was challenging. She was nonverbal, sullen, and lethargic. She told me she was being forced to meet with me, but she had no plans to talk about her problems.

We sat silently during that first session. Ten minutes before our allotted time, I assured Jennifer that I was her advocate, not her father's puppet. I told her I would request her father's presence, and with her permission, I would discuss the family's history with the two of them. Jennifer responded by saying, "Good luck. You'll never get my father in here." I told her, "We'll see what I can do." Handing her my business card, I promised I would be there for her twenty-four/seven, and that she could contact me on my cell phone. Looking surprised, she pocketed my card and

left. She told me later that she had never had a number she could call in the middle of the night if she was in distress.

After firm insistence, her father reluctantly consented to a session. As I uncovered some of the layers of the family's history, I slowly assembled a picture of Jennifer's home life. She had essentially been left on her own since the age of eleven and, in my estimation, she had actually coped rather well. Although I suspected that deeper, more damaging revelations would be forthcoming, I felt that the first order of business was to make her current situation at home more acceptable to both father and daughter. Jennifer's father agreed to suspend the sentence of lifelong grounding, and Jennifer agreed to a negotiated set of ground rules at home. After devising some simple guidelines for Jennifer's recovery, we all agreed to meet together in several months.

In the sessions that followed, Jennifer seemed somewhat improved, but she remained reluctant to delve deeper into her problems. At the end of each meeting, I reminded her that she always had my number, if she ever needed to call me. Eventually, as I slowly won her trust, she started to confide in me. At the same time that I was trying to unearth Jennifer's underlying emotional problems, her school counselor and family doctor were dealing with her poor physical health and educational setbacks. It was up to Jennifer and me, however, to ascertain what had gone so wrong, and why she cared so little about her own well-being.

One day Jennifer arrived in my office with a letter from her mother, which she asked me to read. I found it superficial and chatty. Jennifer asked me what I thought of it, and I told the truth. She burst into tears and allowed me to comfort her. For an entire hour, the girl who had spoken barely a word, poured out her heart.

Well before the divorce, Jennifer had felt abandoned by her parents. As a child, she had mistakenly assumed that there was

something dreadfully wrong with her, and that she was somehow responsible for her parents' problems. In subsequent sessions, Jennifer revealed an even harsher truth: molestation. Several men, including one of her father's best friends, had repeatedly molested her as a child. In the years that followed, Jennifer was promiscuous with men and then began experimenting with other girls. She admitted that the best sexual relationship she had ever had was with another girl. Jennifer suffered deep shame in her preference for women, and we traced her promiscuity back to that secret. She had convinced herself that if she slept with enough men, she could not possibly be gay. Knowing that her father was homophobic, talking with him about her fears was out of the question. As her secrets compounded, Jennifer retreated into her solitary world of self-loathing and alcoholism.

After months of therapy, Jennifer allowed me to bring her father into another session. By this time, she was doing better academically and cooperating with the ground rules at home. The session began by Jennifer confronting her father about leaving her alone for so many years. As she talked about how much she had missed her parents while growing up, the tears began to flow. Suddenly, the defiant, hostile teenager transformed into a sad, young girl. With my encouragement, her father began to comfort her, and the seeds of a new relationship were planted. They both agreed to spend a day and an evening together each week, getting to know one another.

After several months, Jennifer was ready to tell him the truth about the sexual assaults and her homosexuality. She explained that she had trusted his friends and was afraid to tell him what had occurred. The revelations were difficult for her father to accept, but he desperately wanted his daughter back. They both worked hard to accept one another. Over time, Jennifer

blossomed into a happy college student, with a life of possibilities ahead of her. She became a committed member of Alcoholics Anonymous and was no longer promiscuous. Eventually, her father came to accept her sexual preference and was simply grateful to have a healthy daughter back in his life.

Knowing the long-term damage of sexual assault makes our statistics relating to assault unacceptable. They indicate to me that we have a great need to talk openly with one another and particularly to young girls. Women have increased their financial and social power, but it is equally important that they address the protection of their physical selves as well.

politics and religion

Two of the most difficult subjects to discuss among friends are politics and religion. Opinions in these areas often run deep within us and are not easily changed. It can be a test of any friendship if these opinions are vastly different. Avoiding these subjects may seem an easy solution, but it isn't always the most beneficial to a deep friendship. Asking your friends questions about how and why these opinions were formed can open the door to new understanding. Agreeing to disagree with respect can strengthen the bond between friends. Very often, our families and life experiences shape our views. Loving your friend and accepting her views is a test of tolerance and unconditional love. It's rare to feel simpatico on all issues with another person. How you handle the differences will shape the future of the friendship.

For me, politics didn't become a taboo subject until the 1990s. In the 1970s, when I was in college, politics was the main subject of our discussions. The reactivation of a military draft made people

suddenly political. I cannot remember one of my friends having political beliefs different from my own. It was an exciting time, and we saw our activism rewarded by creating change.

we live in such a politically divided country, and this subject has greatly influenced some of my friendships. I used to feel so strongly about my political position, and I couldn't understand why some of my girlfriends didn't share my philosophy. I think we were all trying to get past this obstacle, but none of us talked about it very often. When someone has such a different viewpoint about something this important, it's hard to imagine that they are similar to you at all. I guess if you love the person, you overlook her political position and persevere.

Today, I am not as politically engaged, and I hardly know what's going on. I have become comfortable and more concerned with my own life, and less about the world. I don't like this. I now want to get more involved again, but when I talk to my girlfriends, they often have very different political allegiances. Some of them are influenced by their husbands, some by their newfound social and economic status. I miss my old friends from my college days, some of whom have passed on, and many who have moved away. I have found out the hard way that discussing politics over dinner in suburbia is not a good idea.

Another taboo topic among friends is religion. Religion is such an abstract subject and faith is very personal. Creating an environment that respects the right to believe anything and not demand anything from your friends will allow your friendships to flourish, even if different belief systems are in play. This story, from one of the women we spoke to, illustrates just how divisive religion can be:

I had a really good friend in high school named Connie. She and I both belonged to a Christian youth group in our area. I really enjoyed it, and we took several trips that I will remember forever. When we got to college, my friend became very religious and began to practice a fundamental faith. It really would not have bothered me, except every time we were together she tried to convince me to join her church. She said things like, "You will go to hell if you don't accept Jesus Christ as your personal savior." She was so sure of herself; there was no discussing the subject. When I finally told her outright that I was never going to attend her church, she said some very unpleasant things and refused to take my calls. It still baffles me that she could not accept our friendship, even though there were differences in our religious philosophies. I certainly didn't object to her beliefs, I just wish she had respected mine. It's been years since I last saw her, but I still miss her presence in my life.

money

Money has become an interesting issue for me with my girlfriends. I earn a lot more money than some of my girlfriends. But, in other

friendships, I'm the one who has much less. I think it's important not to flaunt one's success and to make it easy in social situations for the person who has less money. I smile when I think about how my wealthy girlfriend buys me lunch, and I turn around and buy dinner for another friend who is struggling financially. Either way, money has never come between my real girlfriends and me. In my practice, however, I have often witnessed how money can corrupt a friendship.

i have a friend who is very wealthy. She invited me to her home in Italy for a vacation. It was a generous offer, but I ended up in several awkward situations. She took me shopping to these designer stores that I could never dream of affording. She would buy five or six pairs of shoes, spending thousands of dollars in under an hour. She continually asked for my advice on what to buy, or not buy. Before I knew it, I felt like her assistant. She had me running all over the store, trying to negotiate with the shop assistants in my limited Italian. On top of this, I felt that she was rude to the shop staff. I have never been able to talk to her about it, and I probably never will. I felt demeaned by her attitude, and I didn't like the position that I felt she put me in. Perhaps more important, she had no understanding or awareness of my discomfort while we were in the store. I think seeing her act this way scared me a little. The trip was an exciting adventure, but the situations that revolved around her money and her shopping put a distance between us.

Of course we all want to have money, or at least we think we do. Some of us believe that money will solve our problems, that it will bring us finer possessions and higher-quality friendships. What I have found in my practice, however, is that this is not the case. People can be happy and fulfilled whether rich or poor. Money has little to do with it. As the saying goes, "We have everything we need to be happy right now." In fact, having wealth comes with its own set of burdens. One of the women we surveyed said:

> I don't have any girlfriends. I really don't trust women much at all. I come from a wealthy family and have always been blessed with a luxurious lifestyle. There were girls that I thought were friends, but they were using me for my contacts and/or my possessions. I would have given them anything, but when situations arose, I felt they betrayed me. It became apparent that I was being used, and when I was no longer needed, I never heard from them again. I've had other women try to seduce my husband practically in front of me. A lot of women act like sharks in a feeding frenzy when they are in the company of a wealthy man. Now I only hang out with my family, especially my sisters. Maybe someday I'll experience a true girlfriend, but it hasn't happened yet.

I am always interested in observing my clients' relationships with money and how they relate to others over this issue. I have rich clients who feel poor and poor clients who feel rich. It seems that money is more than an amount in your bank account; it's truly a state of mind. People are often secretive about their money. How much they earn and how much they

have in the bank (or owe to the bank) is often considered to be extremely private. It usually takes some time for new clients to share this sort of information with me. Often they express relief that there is someone to finally share the details of their financial life. Discussing this subject with a trusted girlfriend can be very helpful, especially in times of transition. A friend can sometimes help you sort out difficult financial decisions. It is an honor when someone trusts you sufficiently to share this type of personal information, and it should never be repeated to others.

I have a female client who began a "get out of debt" club with her girlfriends. They met every week and talked about how the week went in regard to money. They shared the details of their debt and helped each other make a plan to get out of debt completely. Within a year, they were all debt-free. They continued to meet and renamed it "the savers' club." Their new purpose was to save for their futures. Once again, they helped each other devise a plan. They created budgets, opened savings accounts, and eventually several invested in real estate together. They described how close they all became as friends. They enjoyed their evenings together and were proud of their accomplishments. They all admitted never speaking about their financial details to anyone before. Several women in the group were binge shoppers. The group served as a supportive place to investigate what the excess shopping was really about in their lives. Two of the women subsequently sought therapy as deeper issues were revealed. They all started making connections between overspending with overeating and overdrinking. Feeling connected in a loving way helped fill the void that these women were attempting to fill with material possessions. Most important, when they felt the need to spend recklessly, they had each other

to reach out to for support. One woman described a shift from feeling powerful in the mall buying something to feeling powerful walking into her bank and seeing her substantial savings balance. Their group was a true triumph for girl power and demonstrates the benefit of discussing "taboo" topics.

Health Issues

A serious illness in a family can also be a very difficult subject to discuss, even with close friends. Sometimes the person doesn't know where to start or doesn't want to "burden" a friend. Sometimes, she might be afraid that if she opens up, she'll fall apart. As a therapist, I encourage people to open up, even if they do break down. It is so much better to release rather than contain these hard feelings. Going through a physical catastrophe can be so isolating, especially after the initial outpouring of concern. As a girlfriend, it's important not to avoid the difficult situation your friend is experiencing. Sometimes people avoid the topic because they are afraid to remind the person of it, when actually a difficult health issue is never off the person's mind. Gently ask questions. Call often. Send cards and offer support. I once had a family member fighting cancer, and one of my girlfriends dropped off fresh groceries every day on my porch. She never even asked what I needed, she just knew. Another friend put dinner in our refrigerator every night for weeks. It was a godsend. They dragged me out to dinner and let me cry and eventually laugh again with them. They are still a special part of my "best friend" circle.

Another topic that was taboo for many years was AIDS. We have to trust that our friends will support us, whether it concerns

AIDS in our family, our inner circle, or ourselves. Some close friendships have been severely tested in this regard, and many have ended because of the issues associated with not only this disease but a host of others as well. Fear is a natural reaction to unknown factors, and certainly AIDS continues to baffle the experts. But educating ourselves and our friends about the risks and the myths will help to alleviate the anxiety. Thankfully, as the stigma of this disease lessens, the reticence to talk about it with our friends has decreased.

my brother was diagnosed with AIDS in the early 1980s. No one knew much about the disease at that time, and everybody was starting to become really afraid of it. The paranoia surrounding AIDS left me with a secret that I didn't even share with my closest girlfriends. I was afraid that if they knew the true nature of my brother's illness, they would not want to come to my house, or swim in my pool, thinking that maybe my brother had contaminated it. It was an awful time! Our neighbors even had a special meeting of the homeowners' board to discuss whether my brother should be allowed in the community pool. When I finally couldn't stand the separation from my girlfriends, I broke down and told them the truth. They completely embraced me and helped remove shame from my feelings about my brother's illness. Their love helped heal my entire family.

\mathcal{G}irlfriend therapy

1. Do you have secrets you keep from all/some of your friends? Why?

2. Would it be beneficial to share your secrets with a trusted friend? List the pros and cons, remembering that many of our dark secrets really aren't that dark, and that sharing them often brings great comfort and casts an entirely new light on our situation.

3. Which of your friends do you think truly have your best interests at heart?

4. Do you foster feelings of acceptance among your friends?

5. Do you accept your friends without judgment? If not, what is that costing you in terms of friendship?

6. Sexual assault is rampant. Are you vigilant about staying safe?

7. Do you teach your daughter and other young girls the importance of personal safety, and caution them to be careful even among their friends and on dates?

senior
friends 10

I F WE ARE fortunate enough to have a long life, we will probably end up living in the company of our girlfriends. Ninety percent of all women will live without a mate at some point in their lives. Considering the fact that men generally have a shorter lifespan than women, even married women face the prospect of living alone in their senior years. Nursing homes, community recreation halls, senior centers, and even beach clubs are filled with groups of women enjoying each other's company. They play cards, board games, and bingo. They swim together, dine together, and even travel together.

Due to the high divorce rate and large number of never-married women in our society, more women are now living together earlier in their lives than ever before. Women also have more of their

own money and are pooling resources to live a better lifestyle. I know groups of middle-aged women who are planning to retire and live together in their aging years. They tease each other about taking good care of their health and keeping a good attitude, so that it will be fun to grow old together. Some of them even invest in property together, to ensure their quality of life in later years. The fact that many baby boomers chose not to have children has also brought the question of aging alone to the forefront. Childless women used to be afraid that there would be nobody to care for them when they were old. Many now realize that nursing homes are filled with people who have children. Many savvy women today have decided that their own money, coupled with a strong girlfriend network, will ensure them a better situation in their old age than if they had had children who were expected to care for them. Because they have their girlfriends, they are not afraid. By pooling their money, they can look forward to a beach house with round-the-clock care instead of a nursing home! They do not fear old age, because their "new girls' network" will simply segue into the "*old* girls' network."

the girlfriend continuum

Growing older with girlfriends may go on for many wonderful years, but then many women experience the loss of their aging girlfriends and find themselves truly alone. This is often the most difficult time in a woman's life. It is when true isolation and loneliness can begin. The solution to this situation is, of course, finding new girlfriends!

Anyone who has an older person in her life that she can call "friend" has a rich treasure.

In the play *I'm Not Rappaport*, the two main characters, Nat and Midge, both old cronies, sit on a park bench each day and pass the time with each other. The rest of the world rushes by, oblivious to these two old guys. One of them turns to the other and says, "What's wrong with them? Don't they realize that we're the coming attraction?" Many people treat the aged as though they are invisible. Younger women need to realize that friendships that cross the so-called "age barrier" have much to offer both them and the older person. There is no doubt that our older girlfriends are definitely the "coming attraction." We need to honor and learn from them. I love to hear my friend Lyndie talk about one of her best friends, named Annie.

Annie will never reveal her true age, but it's clear that she is "way up there." Annie has a spirit that soars, and so she is "way up there" in more ways than one! Her humor, her wisdom, her support, her spiritual guidance, and most of all, her unconditional love give me a sense of having another mother in my life. This is especially important to me, since my own mother passed on more than fourteen years ago. The story of how I met Annie is one that we can all learn from when it comes to making friends.

Many years ago, a nice but boring guy invited me to go out on a date. No, it wasn't for a dinner or an evening at the movies, it was an invitation to go to a church lecture! "OMIGOD!" I thought, "What could be worse?" Of course, my first reaction was to think of a good excuse and say "Sorry, I'm busy," but instead I heeded the advice of my mother, who always used to tell me "Say yes, honey, even if you don't like him, because you never know who else you might meet when you're out with him." When the young

man picked me up that night, he explained that he had to pick up another couple from church who wanted to go to the lecture, but who were too old to drive. Hmmm . . . I did not see this as a good start to a night that I was already dreading!

Before I knew it, Annie and her husband Phil were climbing into the back seat of the car, and we were off on a double date to hear a lecture on the power of prayer. What I remember most about that evening is Annie's quick wit. My date was a bore, but Annie was a hoot! Laughter filled the car both coming and going.

The church lecture turned out to be thought-provoking and inspiring, and the strangers in the back seat were people that I immediately felt drawn to. Annie and Phil were interesting, vibrant, caring, and just plain fun. I couldn't wait to see them again. We exchanged phone numbers, and that was the beginning of a lifelong friendship. There were many evenings that I was invited to dinner with them. Annie and I would often go out for tea together. I'd sometimes go shopping and then bring my purchases over to her apartment for approval and admiration. Annie came to visit my kindergarten classroom, and she would tell stories to the children (older people always seem to have the best tales to tell). Whenever I got a bad haircut and was in "hair hell," the first person I called was Annie. "It'll grow, darling, and nothing can spoil your pretty face. Meanwhile, you can borrow one of my hats!"

Even though they were decades apart, it was clear how much Lyndie and Annie had in common and how much they enjoyed each other's company. As the years went on, Annie's own daughter

(also named Linda) moved to Washington, D.C., and the friendship expanded so that "Linda #1 and Lyndie #2" (as Annie likes to call them) became best friends. Annie and Lyndie have seen each other through many different stages and life changes, and their friendship continues to be solid and soulful.

how to meet senior friends

1. Start with your neighborhood. Introduce yourself to all your neighbors.
2. Invite new acquaintances of other friends to holiday celebrations or spontaneous barbeques.
3. If you attend a church or synagogue, you could ask the director if there are older people in the church who could use a hand, or just some company.
4. Nursing homes are filled with folks who would love a visit—contact a local facility.
5. Meals on Wheels and hospices can be a source of people who would benefit from your care and contact.
6. Be aware of all the opportunities in your daily life—take a chance and reach out with love and friendship.

The key to the success of their friendship is that Lyndie recognizes Annie's great wisdom. She knows that the experiences and knowledge that Annie has gathered along the way are unique treasures, and she makes every effort to learn from her older friend. Life is a complicated journey, and senior friends are survivors. There's no doubt that they have much to offer. But, even more than being survivors, older friends are indeed the "coming

attraction." It's important to pay attention to the qualities that have allowed them to stay strong, laugh readily, and keep going. Annie always likes to remind Lyndie, "You know, honey, there must be a reason that I've lived this long, and I think it's because I have to take care of you young chicks!" We should all be so lucky to have an Annie in our lives. Such friends allow us to look forward to becoming the coming attraction.

Several times in my life, I have befriended older women in my neighborhood. I enjoyed sharing holidays, making emergency runs to the drugstore, helping out with maintenance issues around the house, and doing some of the things that they now found hard to do. Some of the women I befriended over the years made it a joy, and we developed a true and reciprocal girlfriend relationship. I learned so much and treasured the time that we spent together.

However, several of these older women I tried to befriend proved difficult, and I grew to dread my visits with them. This was sad, because I knew how lonely they were. Unfortunately, I could not get past their contrary, negative demeanor. It drained more energy than I had to give. The therapist in me analyzed why this was so, because I wanted to become an older person whom younger women enjoyed befriending. I realized that older women also need to give back.

i am thirty-nine years old and my best friend is seventy-eight years old. She's a very special person. She's always there for me. I speak to her on the phone or I see her every day. She was there for me when my parents died. Any time I need to talk she's right there.

For instance, there was a woman I would visit after work and bring whatever she needed that day. I would arrive tired and hungry after eight hours at the office. She never once offered me dinner or even a snack, even after I hinted that I was hungry. After an hour or so, I was so famished I had to leave. She always begged me to stay longer, and I always felt guilty when I had to go. I made a resolution that when I am an older woman, I will always cook for my friends who visit or take care of me. Young people so often lack the time or the expertise to create homemade meals. A pot of soup or a pan of lasagna can be a nurturing treat at the end of their working day and would be a welcomed gesture of reciprocation. I would have extended my visits had food been offered. Even though older women need more assistance and have fewer family and friends to provide for them than younger women, it behooves them to find ways to reciprocate.

reaching out

As the aging process unfolds, we tend to obsess over how we feel physically, our aches and pains, our bowel movements, our forgetfulness, and so on. Some people evolve into cantankerous, complaining experts on everything, making it difficult for younger people to relate to them. If we are in our eighties, it should come as no surprise that we are unable to do what we did as a younger person. Constant negative haranguing, however, drives young people away who may otherwise have enjoyed and benefited from the friendship. Each of us faces the hard truth that if we are blessed with longevity, we will experience declining health.

It's natural to envy the health and vitality of young people, even to resent their apparent ignorance of how lucky they are. From the vantage point of old age, it's natural to think, "Youth is wasted on the young." But we, too, were once young and ignorant and complacent with our supple limbs and pain-free joints. We must put aside our resentments and celebrate our young friends' lives, without burdening them with our problems of old age. Young friends will keep us vital, and we need to nurture those friendships.

The temptation to complain about the present-day world is one that needs to be avoided. Life is constantly changing, and the happiest people embrace that change. "The good old days" syndrome is tiresome to younger friends. Letting yourself be amazed and curious, rather than critical of the dizzying modern-day world, will keep you young at heart and a pleasure to be with as a girlfriend. We must work hard to hone the skills needed to keep young people in our lives. We must listen to their dialogue and appreciate their problems.

Aging can be so frightening that we may forget that young people struggle as well. As older persons, we should ask ourselves how we might contribute to the lives of our younger friends. I know a woman who began giving her jewelry and her fur coats to the younger women in her life. She explained to me that she no longer wore these things and took great pleasure in watching how her young friends enjoyed them.

Another woman understood that time was an asset that she could share. She chose to babysit for one of her young friends. She enjoyed her time with the children, and this allowed her young girlfriend to have a romantic night with her husband once a week. Reciprocation makes friendship a two-way street, and that is impor-

tant regardless of the age difference between girlfriends. My mother now reads to local school children on a regular basis and tells me it's an amazing and fulfilling part of her life.

If, as an older woman, you allow yourself to become a bottomless pit of need, people will avoid you. Being grateful for what someone provides encourages the giver. If what one offers never seems to be enough, the natural response is avoidance and withdrawal. To expect that anyone would willingly return repeatedly to the company of an unpleasant person is unrealistic.

A sense of old age "entitlement" is invalid, and it certainly is not conducive to maintaining youthful friendships. Regardless of our age, the more our definition of friendship includes service to others, the more likely we are to enjoy a network of girlfriends.

My friend Lyndie always speaks about her amazing Aunt Virginia. As luck would have it, when I moved to Florida, she lived just five miles away. I decided to give her a call, and Virginia turned out to be one of the most engaging, entertaining, and thoughtful women I had ever met. It didn't take long for us to realize how many common interests we shared, and she quickly became one of my best friends. Virginia had been the beauty editor of *Prevention* magazine for many years, and she had always been dedicated to a healthy lifestyle. We both practice yoga and meditation, and we both eat a natural food diet. We both exercise at the gym and enjoy walking in our neighborhoods.

One of the keys to our friendship is the fact that Virginia never makes me feel guilty about my chosen fast-paced lifestyle, and she always seems thrilled with any time that we can share. She delights me with homemade goodies. She offers insight and wisdom in every conversation. And I have never heard her complain about anything. Virginia has taught me that age is relative,

and if I complain about my age, she reminds me how young I really am. Instead of finding our time together draining, I feel nourished. I always look forward to our next time together.

As it turns out, Virginia and I are collaborating on a book titled *Ten Steps to Ageless Beauty*. Who would have thought that one phone call would turn into an exceptional girlfriend experience? Virginia is the consummate role model on how to make friends later in life.

the circle of friendship

My first realization that I had a girlfriend occurred when I was six years old. Barbara Wege lived in an apartment upstairs, and we knocked on each other's door all the time. Together we would race into the concrete alley that we considered to be our personal playground and play with a little pink Spalding ball. We would entertain ourselves for days on end. I realize now how much I loved Barbara Wege. She was important to my life, for she was the first real friend I ever had. Although I moved away at the age of eight and never saw her again, Barbara Wege will always be an integral part of my foundation of friendship.

It's clear to me how critical the early years and the middle years, as well as the later years of friendship, are to the quality of our lives. From playing with pink balls in an alley to collecting shells with senior friends on a beach, the quality of our lifelong assemblage of girlfriends largely defines the quality of our lives. No matter how much time we like to be alone, all human beings need connection with others. In our later years, that connection will often come from other women. Believing that you have something

valuable to offer, combined with a willingness to approach life with a positive, selfless attitude, can spare you from the isolation and loneliness some women experience in their senior years.

meeting new friends as a senior

1. Be involved in your church, synagogue, or local senior citizens center. Make it a goal to invite someone over for coffee or cocktails.
2. Be aware of your neighbors. Is there a young mother or single woman you can help out in any way? Are there neighborhood kids who could benefit from some mothering?
3. Stay positive and creative about your life—it's a magnet to others.
4. Participate at your local school, reading to children or helping on holidays.
5. Take a class or join a club—learn a language, a new cooking skill, or how to play bridge.
6. Make a vow that every time you leave the house, you will try to engage one stranger, even it's simply to nod and say "Hello." This will put you in a receptive frame of mind to meet new people.

\mathcal{G}irlfriend therapy

1. What are the ages of each of your friends? Write the numbers next to the names on your girlogram.

2. Do you have friends in different age groups?

3. Do you have old friends as well as new friends?

4. Do you contribute as well as receive in each of these friendships?

5. If you are young, what can you do to make a new senior friend?

6. If you are older, what can you do to make a new younger friend?

7. Set a goal to broaden your girlfriend continuum.

the girl's guide
to friendship

As I APPROACHED the end of this writing journey, I came to see that successful girl-friend relationships are governed by some simple ground rules. As I reflected on the rich tapestry of friendships that have blessed my life, a "Girl's Guide to Friendship" took shape. Though simple, they highlight fundamental principals that strengthen our relationships.

When you evaluate your own girlogram, you should think about the kind of friend you are and the kind of friend you want in your network. Discussing these guidelines with your girlfriends will generate some powerful, constructive girl talk. You may find yourselves adding to the list of guidelines or changing some of them to suit your particular friendships. Most importantly, you have begun the process of honoring your friendships by defining and clarifying them.

1.
choose only people you are proud to know

*Tell me who admires and loves you, and I will tell
you who you are.*
—CHARLES AUGUSTIN SAINTE-BEUVE

Choosing a friend is one of the most important decisions in your life. A true friend is one in whom you can confide your deepest thoughts and experience the exquisite pleasure of female bonding. A person's moral fiber and strength of character will directly affect the quality of the friendship that you can achieve with them.

When selecting a friend, consider whether you would like your children to emulate this person. What would your family think of her? Your other friends? Although we do not choose our friends based on others' standards, we cannot minimize the impact that each new friend has on our entire circle. No friendship stands alone. Each is a thread in the fabric of your daily life. Consider your friends as extended family. Remember the old proverb: "Show me your friends, and I will tell you who you are."

2.
lead thoughtfully, with love

Friendship is not a big thing.
It's a million little things.
—ANONYMOUS

Love is the strongest force on the planet. Once you have selected a person to be your girlfriend, then it is safe to let your love surround her. Consider it an honor to be included in the family of your friends, and each of your friends should feel the same way. For your part, it is important to nurture your friendships with thoughtful, unselfish kindnesses. One clear expression of your love is to listen carefully to what your friend requires: if she needs to vent, listen with sympathy; if she needs encouragement, offer it; if she needs to feel loved, give her a hug. Remember, it's a million little things.

3.
be open and honest

Friendship is the inexpressible comfort of feeling
safe with a person, having neither to weigh
thoughts nor measure words.
—GEORGE ELIOT

If you believe that you can trust a girlfriend, it is vitally important to be as open and honest as possible with her. When you tell

the truth, you give the friendship the best chance to thrive. The moment you disguise your feelings, you have begun to erect a wall within the friendship. The truth keeps our channel of connection clear.

4.

listen without judgment

What most people need is a really good listening to.
—ANONYMOUS

Many of us harbor secrets that we are ashamed to share with our friends for fear of condemnation. When a friend confides in you, therefore, you must be extremely sensitive to your outward reaction. Advice is rarely what a person truly seeks. Rather, she merely needs a forum of safety and unconditional love in which to find her own answers. You may not approve of what your friend is telling you, but it is important that she feels loved all the same. You can dislike a type of behavior yet still like your friend.

Listening without judgment bestows the grace of intimacy. It allows a friend the freedom to explore her feelings, without the fear that you will judge her. Remaining nonjudgmental allows you to stay close to your friend and supports open communication.

5.
respect boundaries

The friendships which last are those wherein each
friend respects the other's dignity to the point of
not really wanting anything from him.
—CYRIL CONNELLY

Whether it is privacy, possessions, ex-boyfriends, or time alone, everyone has an invisible web of boundaries that requires respect. Sometimes a person isn't ready to share a secret or lend her car—or even a book. Boundary cues can be subtle, so your sensitivity must be in full gear. If you detect a note of hesitation or a hint of distress, pause a moment and consider the boundary signal you're being shown. Respect the right of each of your friends to protect what they hold sacred.

When men enter the picture, boundary flags are often raised. Single women should discuss with their friends their unwritten code with regard to meeting men and dating them. One client told me that one of her boundaries was: "Once I kiss a man, he is off-limits to my girlfriends, and vice versa." Women also have complained about girlfriends dating their ex-boyfriends and ex-husbands. They experienced a sense of betrayal and felt they could never be a true friend with that person again. Open discussions are important so that each person knows the consequences. Be aware of your friend's boundaries, and respect them.

6.
never betray a friend

*To be trusted is a greater compliment
than to be loved.*
—GEORGE MACDONALD

Trust is hard earned and easily shattered. Some of the saddest stories reported during the writing of this book involved the betrayal by a close friend. Often the betrayal was over a man or a lover. Often it was the violation of a secret. Before betraying a friend in any way, consider the hurt your actions may inflict. Put your friendships first. Betrayal by a girlfriend can cause grave and lasting injury. Choosing friends with good moral character can preclude your being hurt.

7.
be there in times of need

It's the friends you can call up at 4 AM that matter.
—MARLENE DIETRICH

When I counsel a client in a desperate situation, I ask her about her support system. Often she replies, "I try to tell my friends, but they just don't get it." Sometimes people only hint at their problems, hoping you will somehow intuit the situation fully. Whenever possible, read between the lines and try to offer assistance even if a request is not forthcoming. Once, in a particularly challenging financial time of my life, a friend of

mine detected stress in my voice and asked what she could do to help. I resisted telling her the truth, because I was embarrassed at my situation. She insisted I come to her office. When I arrived, a check for over one thousand dollars was waiting for me. Needless to say, I was overwhelmed, not only with the overt generosity, but by the fact that she had discerned my dilemma.

One month later I returned the money. (Both she and her husband were incredulous. They said that in all their years of lending money, no one had ever returned it.) They accepted the money on the condition that I understood that the money would always be waiting if the need arose. During my struggling artist days, my friend Barbara cosigned a loan. My friend Maura has also always been willing to help me finance a dream. What this has meant to me is hard to put into words. I would not be where I am today without the help of these beautiful women. Other friends have opened their homes to me, and I to them, in times of struggle. Being there means coming through in whatever way you can to help a friend.

8.
take the time and make the effort

Friendship is like a bank account. You cannot continue to draw upon it without making a deposit.
—NICOLE BEALE

Intimacy requires effort. Returning a phone call, dropping a note, or carving out time to share a meal together waters the roots of friendship. People need to be remembered and feel part of your life. A five-minute phone call can change somebody's

day and remind her that she is always in your heart. Remember birthdays, send thank-you notes, write funny e-mails, drop a surprise goody-bag at her door. Make small efforts with love.

9.
be willing to give—and accept—an apology

Apology is a lovely perfume. It can transform the clumsiest moment into a precious gift.
—MARGARET LEE RUNBECK

In every relationship there are misunderstandings and disappointments. For most of us, there comes a time when we need to apologize for our part of a dispute. It is important not to let pride, stubbornness, or anger get in the way of resolving the issues between you. Even if you feel right in a situation, it's important to say that you are sorry for whatever part you have played. It is helpful to assume that every situation carries a fifty-fifty split of responsibility. Owning up to your 50 percent early on can minimize the damage caused by unresolved friction in your friendship.

Being willing to accept an apology is equally important. From my experience, it appears that many women so dislike confrontation that they allow worthwhile friendships to slip away in a haze of underlying tension. A friendship you've carefully chosen is worth going the distance. Very often, there is a true misunderstanding at the root of the problem. Creating a safe space in which to disagree will keep a friendship healthy and strong over time.

10.
forgive and forget

A good relationship is a union of those who forgive.
—RUTH GRAHAM

An act of bad judgment is not the same as a pattern of poor character. Most people have done something of which they are not proud and regret having done. The fact that one regrets an action and considers it a mistake is what is critical. If a friend does something you deem unacceptable, discuss it with her. Let her know in no uncertain terms that she has crossed the line, then try to forgive her. Without forgiveness, problems will fester beneath the surface and erode a relationship.

11.
keep your promises

Friendship is always a sweet responsibility,
never an opportunity.
—KAHIL GIBRAN

Let your word truly be your bond. Where a friend is concerned, keep your commitments. Your promise needs to be considered sacred, something upon which your friends can depend. Friendships in which plans constantly change and promises are broken never grow as strong as those that are built on consistency and dependability.

In our survey, women reported disputes over their social plans as their leading source of conflict with their girlfriends. What may be an unimportant movie date to you might be the one evening that your single girlfriend looked forward to all week. I have friends who can say, "Let's meet for lunch next Wednesday at one," and I know for a fact they will be there. Other friends might have good intentions, but they need a little reminder. Whatever the level of tolerance you extend to your friends, always strive to be the one who is most dependable. Keeping your promise honors your friends.

12.

be supportive

Friendship is a strong and habitual inclination towards persons to promote the good and happiness of one another.
—Eustace Budgell

A friend who wants to write a novel, or take acting lessons, or join the Peace Corps needs the support of her friends. Of course, we all have our own self-interests at heart, so sometimes a friend's desire runs contrary to our own needs. But we still need to support our friend's flights of fancy, unless they are dangerous, of course.

My move to Florida certainly upset many of my friends. And though many of them hated the fact that I was leaving, they did their best to support my decision. They understood my need to be near the beach, and now they are happy that my new life suits me so well. Being supportive means putting your friend first.

13.

trust the ebb and flow of friendship

True friends are the ones who never leave your
heart, even if they leave your life for a while.
—Anonymous

Sometimes a friendship runs its course and quietly fades from
your life forever. But just as often, a friendship can retreat for a
while or take a separate journey, only to return when the time
is appropriate. Friendships have a life of their own, and some-
times it's unwise to direct their paths. If you see a cherished rela-
tionship with a girlfriend begin to taper off, by all means try to
resuscitate it. But if you're unsuccessful, let it go. Perhaps it will
return; perhaps it will not.

The intensity of a friendship may change, or the amount of
time spent together may lessen. Whatever the cause of the shift
in a relationship, if there is a foundation of love, the friendship
may survive. It may take on a different guise, but it will be there
to rely on.

14.

love unconditionally

A friend is one who knows you
and loves you just the same.
—Elbert Hubbard

Once you have accepted a person into your circle of friends, you
must love her as she is. Trying to change a friend does not

contribute to her growth. If you celebrate a girlfriend's idiosyn-crasies rather than suppress them, she will add a special gift to your life. I find that within my particular group of friends we all have quirks of personality that we expect others to defer to. One of my friends always needs to pick the restaurant and order the wine. Another needs to choose the movie, whereas I need to pick the seats. Still another friend hates to talk on the tele-phone, yet she would never break a plan we make in person. Each of us enters a friendship with past experiences that have shaped us uniquely. For a friendship to thrive, unconditional love is required.

It was fun to think about the most important aspects of being a great friend. My girlfriend Lyndie and I had an interesting con-versation about essential qualities of friendship, so I suggested we separately compile a list of girlfriend guides. When I com-pared our finished products, only two guidelines had to be added to our combined list. Lyndie also provided all of the girl's guide quotes. I sincerely hope that the girlfriend guidelines will be useful for you in your quest for a high-quality network of girlfriends and thank you for coming along on this girlfriend journey with me.

the annechild report on women's friendships

DEMOGRAPHICS

I.D.#

(optional)

Name:

Address:

Phone:

Age:

Ethnic Background: English ❏ Italian ❏ French ❏ German ❏
 Jewish ❏ African ❏ Japanese ❏ Chinese ❏ Korean ❏
 Hispanic ❏ Russian ❏ Indian ❏ Others ❏

Race: Caucasian ❏ Latin ❏ African American ❏ Asian ❏

Never Married ❏ Currently Single ❏ Divorced ❏
 Widowed ❏ Currently Married ❏

Number of biological siblings: How many: Brothers Sisters

Number of stepsiblings: How many: Brothers Sisters

Number of biological children: How many: Boys Girls

Number of stepchildren: How many: Boys Girls

Is your mother presently: Married ❏ Divorced ❏ Remarried ❏
 Separated ❏ Deceased ❏

Is your father presently: Married ❏ Divorced ❏ Remarried ❏
 Separated ❏ Deceased ❏

Personal household income:

Total household income:

Religion or Spiritual affiliation: Catholic ❏ Jewish ❏ Protestant ❏
 Baptist ❏ Christian Science ❏ Hindu ❏ Other ❏

Occupation:

Highest level of education completed:

Present type of living environment: Rural ❑ City ❑ Suburban ❑

Childhood type of living environment: Rural ❑ City ❑ Suburban ❑

How many times have you moved in your life?

How many different states have you lived in?

Which part of the country do you live in? Northeast ❑ Mid-Atlantic ❑
East Coast ❑ West Coast ❑ Midwest ❑ South ❑ Northwest ❑

Do you presently live in an: Apartment ❑ House ❑ Other ❑

Do you presently live: Alone ❑ With a spouse ❑ With a lover ❑
With a female friend ❑ With a male friend ❑

How would you rate your present relationship with your mother: Very good ❑
Good ❑ Fair ❑ Difficult ❑ Nonexistent ❑

How would you rate your past relationship with your mother: Very good ❑
Good ❑ Fair ❑ Difficult ❑ Nonexistent ❑

If you have a sister, how would you rate your present relationship with her: ❑
Very good ❑ Good ❑ Fair ❑ Difficult ❑ Nonexistent ❑

If you have a sister, how would you rate your past relationship with her:
Very good ❑ Good ❑ Fair ❑ Difficult ❑ Nonexistent ❑

How would you rate your present relationship with your father: Very good ❑
Good ❑ Fair ❑ Difficult ❑ Nonexistent ❑

How would you rate your past relationship with your father: Very good ❑
Good ❑ Fair ❑ Difficult ❑ Nonexistent ❑

If you have a brother, how would you rate your present relationship with him:
Very good ❑ Good ❑ Fair ❑ Difficult ❑ Nonexistent ❑

If you have a brother, how would you rate your past relationship with him: Very
good ❑ Good ❑ Fair ❑ Difficult ❑ Nonexistent ❑

	No	Yes	N/A
1. Do you completely trust your closest female friends?	0	1	
2. Would you trust the man in your life alone with your best friend for an extended period of time?	0	1	
3. Do you feel your life has ever been saved by a female friend?	0	1	
4. Do you feel indebted to a female friend?	0	1	
5. Do you feel you have enough time for your female friends?	0	1	
6. Have you ever felt abandoned by a female friend?	0	1	
7. Do you discuss different things with your female friends as compared to the men in your life?	0	1	
8. Do you prefer being in a group of female friends as opposed to being with women one on one?	0	1	
9. Have you ever vacationed with a female friend?	0	1	
10. If yes, was it a good experience vacationing with a female friend?	0	1	
11. Has your relationship with a female friend ever become sexualized?	0	1	
12. If yes, were you single at the time?	0	1	
13. If yes, was it a one-time occurrence?	0	1	
14. Do you feel you've outgrown some of your friends?	0	1	
15. Do you feel confident in your ability to make new female friends?	0	1	
16. Do you think it is hard to make new female friends?	0	1	
17. Do you have a female best friend?	0	1	

	No	Yes	N/A

18. If you don't have a female best friend, do you wish you had one? — 0 — 1

19. Do you wish you had more female friends? — 0 — 1

20. Do you have no female friends by personal choice? — 0 — 1

21. Do you feel more comfortable with friends of similar income levels? — 0 — 1

22. Do you feel more comfortable with friends of similar education? — 0 — 1

23. Did your income level change over the years? — 0 — 1

24. Did your friends change with it? — 0 — 1

25. As your goals changed, did your friends change also? — 0 — 1

26. Do you have any cross-cultural female friendships? — 0 — 1

27. Has a female friend ever helped you get a job?

28. Do you feel there is an "old girls' network" similar to an "old boys' network" in the workplace today? — 0 — 1

29. Are your female friends at work as important to you as your friends outside the workplace? — 0 — 1

30. Do you think of yourself as a feminist? — 0 — 1

31. If you answered no to the above, would you like to be? — 0 — 1

32. Have you ever experienced an abrupt end to a female friendship due to a conflict? — 0 — 1

33. Have you ever experienced jealousy in your female friendships? — 0 — 1

34. Have you been able to work through a disappointment by a close female friend? — 0 — 1

	No	Yes	N/A

35. Have you ever experienced a female friendship that has become personally destructive? — 0 — 1

36. Have you ever put a man or men before your female friends? — 0 — 1
If yes, detail:

37. Have you ever broken a date with a female friend for a date with a man? — 0 — 1

38. If yes, did you lie about it? — 0 — 1

39. Have you ever experienced competition in your female friendships? — 0 — 1

40. Do you prefer socializing with a friend less attractive than you? — 0 — 1

41. Have you ever lent money to a female friend? — 0 — 1

42. If you lent money, were you paid back? — 0 — 1

43. Have you ever been in a dispute over money with a female friend? — 0 — 1

44. Would you rather work for a female than a male? — 0 — 1

45. Has the nature of your female friendships changed as you've aged? — 0 — 1

46. Do you feel it's hard to make new friends? — 0 — 1

47. Do you go to church? — 0 — 1
If yes, how often?

48. Do you feel spiritual?

49. Have you ever felt dominated by a female friend? — 0 — 1

50. Have you ever felt controlled by a female friend? — 0 — 1

	No	Yes	N/A
51. If you are single, are you usually comfortable with your married friend's husband?	0	1	
52. If you are married, do you feel you had more female friends when single?	0	1	
53. If you are married, did your female friends change when you got married?	0	1	
54. Do couples friendships provide you with the same depth as your female friendships?	0	1	
55. Have your longtime friendships been affected by new motherhood? *If yes, how?*	0	1	
56. If you have children, did you feel supported by your female friends as you made the transition to motherhood?	0	1	
57. Have you ever been hit by a female?	0	1	
58. Have you ever been hit by a man?	0	1	
59. Have you ever hit a female?	0	1	
60. Have you ever hit a man?	0	1	
61. Have you ever been sexually assaulted by a female?	0	1	
62. Have you ever been sexually assaulted by a man?	0	1	
63. Have you sexually assaulted a female?	0	1	
64. Have you ever sexually assaulted a man?	0	1	
65. Have you ever sought help for sadness or depression?	0	1	

In your experience with female friends do you feel	Strongly Disagree	Disagree	Mildy Disagree	Mildly Agree	Agree	Strongly Agree
1. Most females often compete with each other.						
2. Females help each other seek jobs.						
3. Females are better to work for than males.						
4. Females are often jealous of each other.						
5. It's good to lend friends money.						
6. It's okay to break a date with a female friend for a date with a man.						
7. It's okay to lie to a female friend occasionally.						
8. Most females cannot be trusted when it comes to men.						
9. Most females are out for themselves.						
10. Most females treat each other like sisters.						
11. Most females stick together.						
12. You had more female friendships earlier in your life.						
13. You had better female friendships when you were younger.						

Choose All That Apply

1. What do you and your female friends fight over most?

 Money ❑ Men ❑ Social plans ❑ Politics ❑ Religion ❑ Other ❑

2. How do you usually resolve these arguments?

 Talk it through ❑ Seek outside help ❑

 Passes with time ❑ Never gets resolved ❑

3. What conflicts prove to be most irresolvable?

 Money ❑ Men ❑ Social plans ❑ Politics ❑ Religion ❑ Other ❑

4. If you experience jealousy in your female friendships, what does it revolve around most?

 Money ❑ Men ❑ Social status ❑

 Lack of attention from friend ❑ Job status ❑

5. What do you feel when a powerful attractive female enters the room?

 Eager to meet her ❑ Intimidated ❑ Competitive ❑

 Jealous ❑ Angry ❑ Neutral ❑

6. In what way has a close female friend disappointed you?

 Not understood you ❑ Betrayed you ❑ Lied to you ❑

 Not been available to you ❑ Criticized you ❑ Other ❑

7. If you have experienced a destructive relationship with a female, what was the nature of the destruction?

 Tore down your self-esteem ❑ Took advantage of you ❑

 Betrayed your confidence ❑ Lied to you ❑

 Humiliated you ❑ Had an affair with your partner ❑

8. If you were in a destructive relationship with a female friend, what happened to the relationship?

 Ended completely ❑ Continued but was different ❑

 Continued and remained the same ❑ Continued and improved ❑

9. How often do you feel lonely?

 Never ❑ Sometimes ❑ Often ❑ Constantly ❑

At the following ages approximately how many times have you	Frequency <6 years old	Frequency 6–12 years old	Frequency 13–18 years old	Frequency 19–22 years old	Frequency 23–present
1. Had a verbal fight with a female.					
2. Had a physical fight with a female.					
3. Had a sexual experience with a female.					
4. Lent a female friend money.					
5. Been disappointed by a female friend.					
6. Been betrayed by a female friend.					
7. Had a man come between you and a female friend.					
8. Had a female friendship end forever over a dispute.					
9. Had a female helped you find a job.					
10. Had a female introduce you to a possible mate.					
11. Been sexually assaulted by a male.					

i can tell her anything

At the following ages approximately how many times have you	Frequency <6 years old	Frequency 6–12 years old	Frequency 13–18 years old	Frequency 19–22 years old	Frequency 23–present
12. Been sexually assaulted by a female.					
13. Ever sexually assaulted a female.					
14. Ever sexually assaulted a male.					
15. Been physically assaulted by a male.					
16. Been physically assaulted by a female.					
17. Ever physically assaulted a male.					
18. Ever physically assaulted a female.					

When did you

	Preschool or younger (<6)	Elementary School (6–12)	High School (13–18)	College (18–22)	(23–present)	N/A
1. First realize you had a female friend.						
2. First realize you had a best friend.						
3. Have your first fight with a female friend.						
4. Have a female friendship abruptly end after a fight.						
5. Feel competitive with another.						
6. Feel jealous of another.						
7. Feel intimidated by another female.						
8. Have the most female friends.						
9. Trust female friends most.						
10. Spend the most time with female friends.						
11. Meet the female friends you now miss most.						

	Not at all	Mildly Unimportant	Mildly Unimportant	Mildly Important	Important	Very Important
1. How important are your female friends to you?	0	1	2	3	4	5
2. How important is your phone contact with your female friends?	0	1	2	3	4	5
3. How important is face-to-face contact?	0	1	2	3	4	5
4. How important is your mother as a role model in your relationships?	0	1	2	3	4	5
5. How important do you think you mother's female friendships were to her?	0	1	2	3	4	5
6. How important are you husband's/lover's opinions of your female friends?	0	1	2	3	4	5
7. How important are your female friends' opinions of your husband or lover to you?	0	1	2	3	4	5
8. How important is the women's movement to you?	0	1	2	3	4	5
9. How important is membership in a women's group to you?	0	1	2	3	4	5

	Not at all	Mildly Unimportant	Mildly Important	Mildly Important	Very Important	
10. How important is it to you to resolve disappointment with your female friends?	0	1	2	3	4	5
11. How important is it to you to resolve disputes with your female friends?	0	1	2	3	4	5

Who do you	Mother	Father	Brother	Sister	Life-long Female Partner/ Wife
1. Trust the most.					
2. Confide in most.					
3. Feel closest to.					
4. Feel knows you best.					
5. Turn to in an emergency.					
6. Turn to in an emotional crisis.					
7. Lean on in a new living situation.					
8. Feel most understood by.					
9. Feel you've been hurt by most.					
10. Enjoy spending time with most.					
11. Like to talk on the phone with most.					
12. Like to enjoy free time with most.					
13. Tell your deepest secrets to.					
14. Feel most yourself with.					
15. Enjoy vacationing with most.					
16. Enjoy working with most.					
17. Have sexual relationships with.					
18. Consider your best friend.					
19. Who do you consider your present family.					

Life-long Male Partner/ Husband	Your Child -ren	Current Male Lover	Current Female Lover	Col- league	Girl- friend	Male friend	Ther- apist	Other

i can tell her anything

1. What was your best experience with a female friend?

2. What was your worst experience with a female friend?

3. Please let us know anything you choose about your female friendships.

1. The concept of selecting friends as opposed to collecting friends is a theme throughout this book. Chapter 1 focuses on the difference between friends of chance, convenience, and choice. When you think about your own friends, where do they fall within these categories?

2. Girlfriends are an integral part of our social system. Carefully considering who the women are that surround you can be extremely insightful. A first step in considering your own social system is to create a girlogram. Those participating in a discussion group should omit each other's names in the construction of their girlogram. This will allow for an open and frank exploration and will avoid hurting friendships within the group. The instructions on how to create your girlogram are in Chapter 2. Discuss with the group how you feel when viewing your girlogram. Are their elements of your girlogram that surprise or disappoint you?

3. Building trust and staying connected are essential in a true friendship. How and when women connect has continued to evolve with each decade. What is your primary method of connecting with your girlfriends? Is it satisfying to you?

4. The author suggests that jealousy and competition often go underreported among women. She maintains that often these feelings underlie much of the conflict that occurs between women. What do you think?

5. Reflect upon the last time you experienced conflict with a girlfriend. Did you resolve it? If so, how, and if not, why not?

6. Have you ever had to end a friendship with a girlfriend? Did reading this book lead you to the conclusion that there might be a friendship in your life that is damaging? Is letting go more difficult than remaining in a hurtful situation?

7. The author suggests the creation of a "new girls' network," not dissimilar to the old boys' network that has existed for years. She believes that the women's movement had a great effect on the women of today. Do you feel that you have been a part of, or affected by the women's movement? Does a "new girls' network" exist in your life? If so, how do you contribute to it, and benefit from it?

8. A majority of the women surveyed disagreed with the statement "Women are better to work for than men." Why do you think this might be so?

9. In considering your girlogram, who are, or have been, your "best friends"? Does the concept of a "best friend" still hold meaning for you? If so, what is it?

10. The issue of trust is fundamental to friendship. The author believes that a woman's relationship with her mother will affect her views about friendship. Do you believe that your mother influenced your ideas about friendship? Would your mother's girlogram resemble your own?

11. In Chapter 9 the author discusses taboo topics. Think about the subjects that you consider taboo and discuss with your reading group.

12. Chapter 10 describes the girlfriend continuum. The fact that women often outlive their mates makes senior friendships more critical than ever to our lives. How do you feel about having friends who are significantly older or younger than yourself? Do you feel there's a risk associated with this kind of friendship?

13. In the Girl's Guide to Friendship, the author describes 14 steps to building better friendships. Which of these steps resonate with your beliefs about friendship? Have you ever skipped a step, and what were the consequences of doing so?

14. Is there any part of the girlfriend experience that wasn't addressed in this book? What might that be?

I WOULD LIKE TO start by thanking Adrienne Ingrum, who had the original and forward-thinking idea that women would be very eager to talk and hear about girl-friends. We worked together on this project for years, and I hope that she is as happy as I am with the final product. From our earliest conversations about a book on girlfriends, I was interested in creating a commercial book that was based on scientifically valid research. I soon learned why that is a very difficult mission to accomplish, and without Dr. Betsy Singh it would have proved impossible. Dr. Singh headed the University of Maryland research team that conducted the fieldwork involving over one thousand women across America. My thanks go to her, the research team, and each and every woman who took the time to complete the survey and generously share their stories with us.

It was Gene Brissie, my hardworking agent, who was respon-sible in large part for this manuscript making it into print. I first met Gene over twenty-five years ago when he was a young fledg-ling editor at Simon & Schuster. I was a flower child with a cookbook about losing weight with natural foods. We couldn't have been more different, but we were thrown together by

circumstance. We fought about almost everything, yet we actually produced a book that was quite successful. Gene and I became great colleagues and friends and went on to publish five more books together. We lost track of each other when I returned to school and studied to become a therapist. Gene went on to build a successful career in publishing. I was given his e-mail address last year by a mutual friend and contacted him after almost two decades. His first question to me was, "What are you working on?" I told him about the girlfriend research, and he said, "Let's do a book!" He then suggested that Carol Turk might be the one to craft a proposal. She did a great job, and even though I have yet to meet her, or to see Gene again in person, this book would still be a dream without them.

Once the dream became a reality, it was my writing partner, John Garner, who brought the book into focus. Always a champion of women, he fell in love with the material and we worked side by side on every sentence. Without his wisdom and his wit, both the author and the book would be vastly different. His relentless energy carried the book forward and pushed me to explore this subject further than I would have imagined. Observing his fascination with this subject made me realize that this was a book to buy for our boyfriends and husbands as much as for ourselves.

I credit Christy Rosché with cracking the da Vinci code between the research we had carried out and the creation of an interesting and helpful book. She helped us see what the book could be and spent countless hours working together with us. If this book is a tapestry of threads, then it is Christy who is its master weaver. She saw what was possible to achieve and pushed us further than we could have imagined. Her brilliant mind and dedicated spirit are at the heart and soul of this book.

Lisa Whybrow was our English angel, slaving away at a computer terminal whenever called upon. Her comments and suggestions also helped shape this book. My dear friend and colleague Virginia Castleton, the former beauty editor of *Prevention* magazine and the author of many women's books, lent her time, wisdom, and experience. Thank you!

Dr. Kathy Burns, of Florida State University, reminded me about genograms at the perfect moment. The idea of a girlogram came to me as I drove home from one of her brilliant lectures.

All of my great girlfriends (in chronological order): Eileen, Lee, Barbara, Lani, Janet, Arlene, Pam, Sharon, Laurelle, Mia, Maura, Johanna, Meridith, Lyndie, Charo, Kathie, Jeannie, Juliette, Virginia, Diana, Christy, Juliette, and Nicola encouraged me and helped in a myriad of ways. Writing this book made me realize over and over again how lucky I am to have these women as my girlfriends. I am forever grateful.

Thanks also to Nolan Haan. Nolan was always ready to read the rough manuscript, and when we sat down for the final manuscript editing, he once again offered his services. He thought he would be concentrating on commas and ended up spending over a week from early morning till late at night working away with me and the team trying to better understand our subject and offer a book really worth reading. His brilliance, humor, and hospitality made for one of the best weeks in forever. And to Mitchell Lambert, whose eagle eyes and line-by-line scrutiny vastly improved the final manuscript. Mitchell was our quiet angel, bringing us treats, drinks, and Cajun lunches. My cousin Mikey shot my publicity pictures for this book on a rooftop in Positano, at the home of our good friends Rick, Paul, Doug, and Everett. These wonderful guys prove every day that a man can be a girl's best friend, too.

Most of all, I need to thank Sue McCloskey, my editor at Marlowe & Company, who put her money where her mouth was. Without her, this book would still be a pile of papers, whose secrets were never to be told. She crafted the pages into a book and found the title for it in her own heart. It is said that no one does anything important alone, and that is certainly true about the book you are holding in your hands.